DARTMOUTH

THROUGH TIME

Ginny Campbell

AMBERLEY PUBLISHING

First published 2014

Amberley Publishing
The Hill, Stroud, Gloucestershire, GL5 4EP
www.amberley-books.com

Copyright © Ginny Campbell, 2014

The right of Ginny Campbell to be identified as the
Author of this work has been asserted in
accordance with the Copyrights, Designs and
Patents Act 1988.

ISBN 978 1 4456 3347 3 (print)
ISBN 978 1 4456 3358 9 (ebook)

British Library Cataloguing in Publication Data.
A catalogue record for this book is available from
the British Library.

Typesetting by Amberley Publishing.
Printed in the UK.

Introduction

The casual observer walking around Dartmouth might be forgiven for thinking that it is a town stuck in a time warp. Narrow streets, medieval buildings, Tudor architecture and old castles all contribute to the feeling that this is a town that time has passed by. However, nothing could be further from the truth. Brian Parker's map on page 6 shows that the physical shape of Dartmouth has changed beyond all recognition over the past 800 years with each addition to the shoreline prompted by the economic, political and social demands of the town throughout time.

Although Townstal (the settlement at the top of the town) is mentioned in the Domesday Book, it is unlikely that the port town existed before the Normans arrived. It was just too dangerous to live close to the river with the threat of Danish attack from the sea. However, with the Norman Conquest and the need for south coast harbours, Dartmouth began to develop with the settlements of Clifton (the early commercial centre of the town) on the south side and Hardness (the centre of shipbuilding) on the north side of the tidal creek that cut through the valley.

With its deep and sheltered harbour, Dartmouth has played a significant role as a port since then. The Second and Third Crusades assembled in the harbour in the twelfth century, and the thirteenth century saw the growth of the wine trade with Bordeaux. In the fourteenth century, Dartmouth had the responsibility of providing ships and supplies to the king as a Royal Borough, including making an important contribution to the siege of Calais in 1347. Castles were built to protect and defend the increasingly important harbour in the fourteenth and fifteenth centuries.

The following two centuries saw ships and men from the River Dart playing a part in exploring the New World, opening up new trade opportunities that would benefit the merchants of the town. Much of the new wealth came initially from the Newfoundland cod fleet, which was later extended into a triangular trade route taking cod to Spain and Portugal, and bringing port, wine and fruit back to England in the eighteenth century. Dartmouth ships helped defend against the Spanish in 1588 when the captured Armada flagship ended up in the Dart. The Pilgrims were in Dartmouth for ten days in 1620 for repair of the *Speedwell*, although only the *Mayflower* completed the journey across the Atlantic.

Despite the loss of the Newfoundland trade in the early nineteenth century, shipbuilding continued as a major industry in Dartmouth until the late twentieth century. Coal bunkering was an important business from the late nineteenth until the mid-twentieth centuries. The arrival of naval training and the railway in the 1860s boosted the economy, and the tourist trade has grown steadily over the last century to become the most dominant industry in the town. Dartmouth is now a particularly popular location for second homes and retirement.

The twentieth century saw Dartmouth play its part in the Second World War, which included loss of life from bombing raids. A contingent of Free French were located at Kingswear, and motor gun boats left the harbour on moonless nights to support the resistance in France. The town provided the Americans with a base for preparations for D-Day, and on 5 June 1944, 485 ships left the River Dart for the Normandy beaches.

Throughout the centuries, Dartmouth's shoreline has changed to accommodate the growing needs of the economy and increasing wealth of traders – first with the damming of the Foss, creating the Mill Pool behind, and later with the reclamation of the New Quay and construction of many of the buildings still standing on The Quay and Duke Street. In times of flourishing trade, construction of buildings in the town reflected this prosperity. Major reclamation in the nineteenth century saw considerable land added to the town, with the filling in of Mill Pool, extension of the South Embankment and reclamation of the tidal pool between New Ground and Mayor's Avenue. Finally, the twentieth century saw Coombe Mud become Coronation Park, and in the late 1980s the South Embankment was widened.

Most of Dartmouth's history has, of course, gone unrecorded in photographs, and the earliest images in this book only date back to around 1860. However, thanks to all the unnamed photographers whose efforts reside mainly in the Dartmouth Museum archives, we are able to obtain a glimpse of what life in the town looked like over the past 150 years and compare it to the town we see before us today. In some places the changes are significant, but there is still enough similarity that Dartmouthians of past centuries could walk our streets and find themselves very much at home.

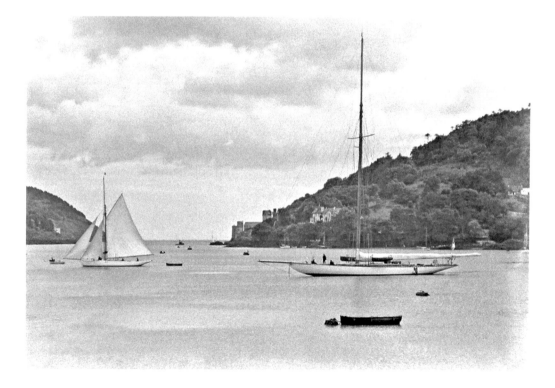

Acknowledgements

My grateful thanks are extended to those who have helped and supported me during this project. Both friends' and local historians' comments, suggestions and corrections have been very much appreciated. I hope readers will find Brian Parker's Changing Shoreline map useful in navigating their way around *Dartmouth Through Time*. I am also grateful to those below, who have kindly allowed me to use their photographs in the book. Unless otherwise stated, the old photographs are from the Dartmouth Museum archives.

Changing Shoreline map by Brian Parker	page 6
John Bowden (top)	page 33
Britannia Royal Naval College Archives (top)	page 38
BRNC Archives (top)	page 39
BRNC Archives (top), Craig Keating (bottom)	page 40
Craig Keating (bottom)	page 41
BRNC Archives (top), Richard Porter (bottom)	page 42
BRNC Archives (top)	page 43
WG Pillar & Co (top)	page 51
Totnes Image Bank (top)	page 84
David Cawley (bottom)	page 87
Dartmouth Amateur Rowing Club (top)	page 95

Dartmouth has two organisations for people interested in local history. Both are happy to answer queries and welcome new members and volunteers: Dartmouth Museum (www.dartmouthmuseum.org), and Dartmouth History Research Group (www.dartmouth-history.org.uk).

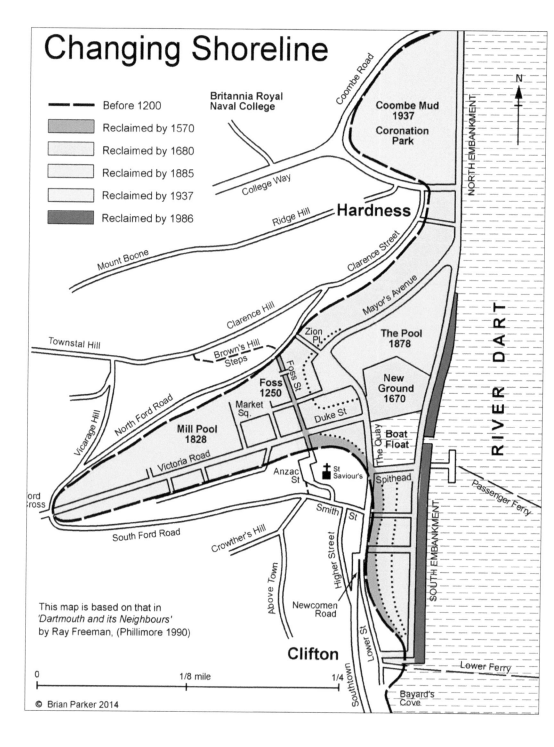

Changing Shoreline

Before 1200
Reclaimed by 1570
Reclaimed by 1680
Reclaimed by 1885
Reclaimed by 1937
Reclaimed by 1986

Britannia Royal
Naval College

Coombe Road

Coombe Mud
1937
Coronation
Park

NORTH EMBANKMENT

N

College Way

Ridge Hill

Hardness

Mount Boone

Clarence Street

Clarence Hill

Mayor's Avenue

Townstal Hill

Brown's Hill
Steps

Zion
Pl.

**The Pool
1878**

Foss St

**Foss
1250**

Market
Sq.

**New
Ground
1670**

Duke St

North Ford Road

Vicarage Hill

**Mill Pool
1828**

The Quay

**Boat
Float**

Victoria Road

Anzac
St

St
Saviour's

Spithead

ord
ross

Smith St

SOUTH EMBANKMENT

Passenger Ferry

South Ford Road

Crowther's Hill

Higher Street

Above Town

Newcomen
Road

Lower St

Southtown

RIVER DART

This map is based on that in
'Dartmouth and its Neighbours'
by Ray Freeman, (Phillimore 1990)

Clifton

Lower Ferry

0 1/8 mile 1/4

Bayard's
Cove

© Brian Parker 2014

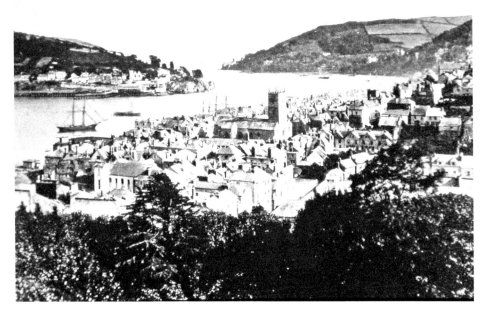

Dartmouth and Kingswear

Overlooking the town from Mt Boone, the view of Dartmouth, Kingswear and the mouth of the river is much the same today as it was in the 1880s. Although now more developed in the foreground and on Kingswear Hill, landmarks of St Saviour's, the station pontoon, market square, Kingswear Quay, Kingswear church and Dartmouth Castle are easily identified in both photographs. Shipping in the river is now predominantly pleasure craft.

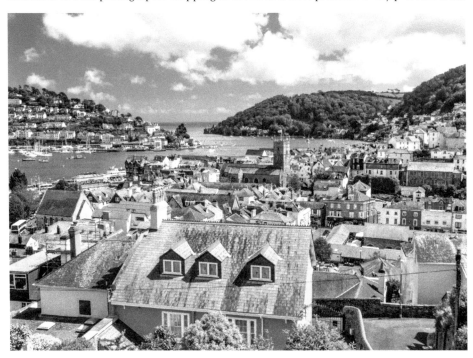

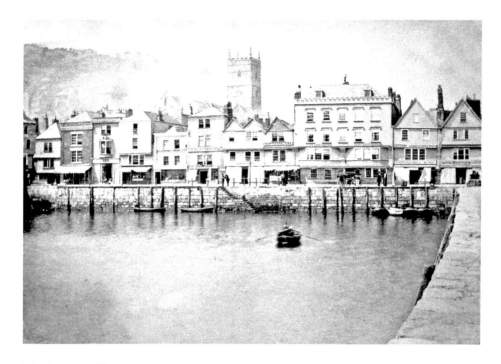

The Quay, *c.* 1867

Dartmouth was once a very different place, since much of the town centre has been built on land reclaimed from the river over the centuries. Wealth, brought to the town by the Newfoundland fish trade in the sixteenth and seventeenth centuries, stimulated major expansion. The new quay was built in 1584. Until then, the tidal mud bordered Lower Street and the church wall, then followed the thirteenth-century dam of Foss Street to the foreshore of Hardness (the current Mayor's Avenue). The New Ground was reclaimed in the 1670s.

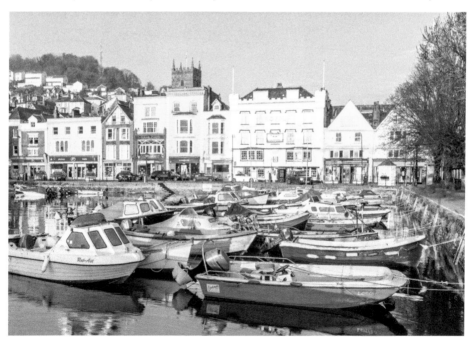

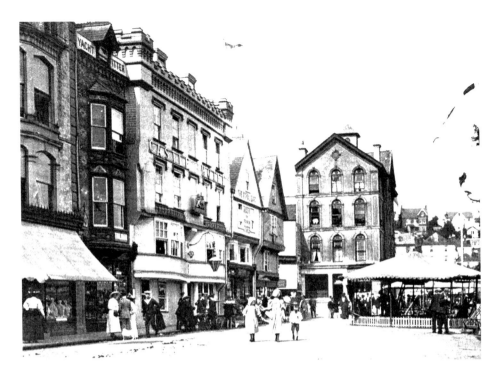

The Quay, 1914

The buildings along the quay have changed very little in 100 years. Gone, however, is Parade House, which was built in 1880 and replaced by NatWest nearly a century later. The bank does reflect the architecture of its predecessor by retaining arched windows, columns, a cupola and a gabled side. Above, the quay is decorated for regatta in 1914.

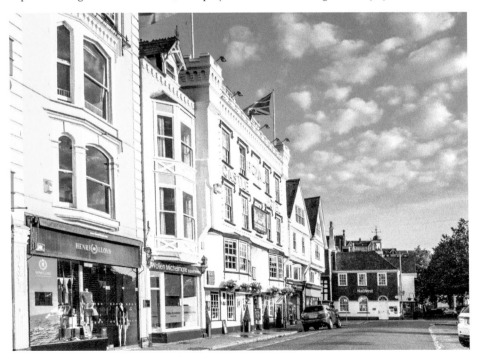

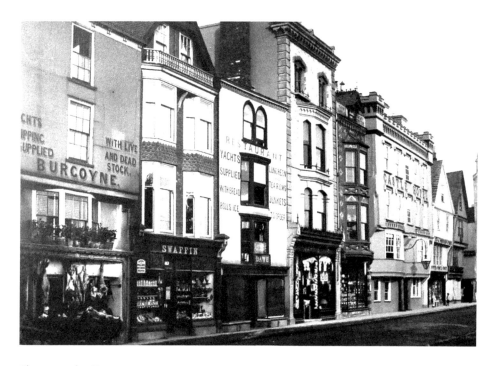

Shops on the Quay

The shops on the quay, seen here in the late nineteenth century, are still easily identified, but the hotel and restaurant are the only two still in the same line of business. There are now many more fashionable yacht clothing shops in the town than in the late 1880s, but yacht provisioning was an important part of local business even then. Cundell's was a notable shop next to the Castle Hotel from 1892 (*see next page*). It was a grocers before the Second World War, calling on customers to take orders and delivering around the coast. It was also a delicatessen before finally closing in the 1990s.

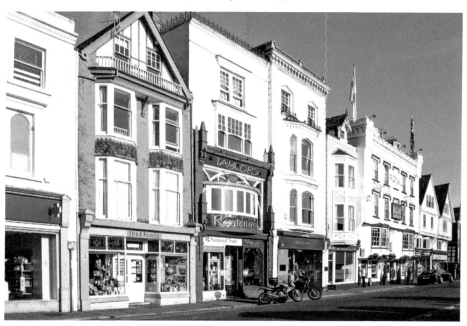

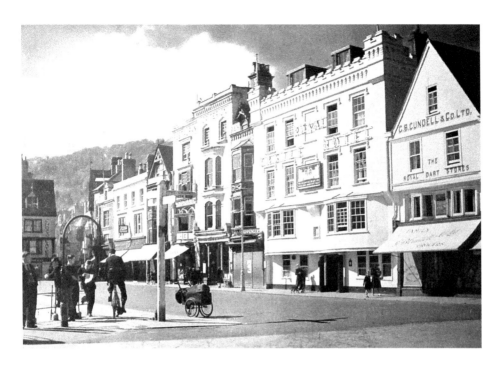

The Royal Castle Hotel

Built as two merchant's houses on the new quay in 1639, one of the properties became the New Inn. The inn was enlarged with the addition of the second house in 1782; later a castellated facade was added. With the building of the turnpike (Victoria Road) bringing easier access to the town in the 1820s, the brew house and stables became a proper coaching house known as the Castle Hotel by 1841. The Castle Hotel became Royal in the early 1900s following visits to the naval college by the royal family.

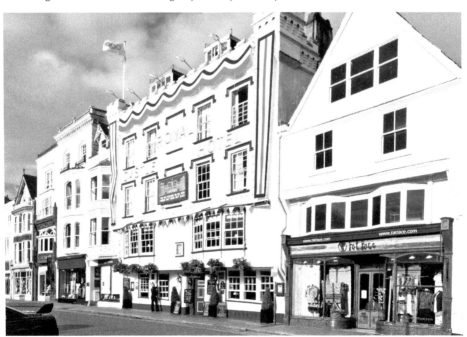

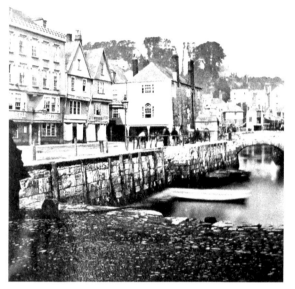

Assembly Rooms

The Butterwalk's eleven pillars were originally thirteen when the Assembly Rooms still stood on the corner of the quay and Duke Street. Originally Mrs Hatton's Coffee Shop, it was a place to meet and socialise as well as discuss business and purchase goods. When Mrs Hatton's closed, the premises became the Assembly Rooms. By 1877 the Assembly Rooms were in such poor condition that the mayor, Sir Henry Seale, requested attending members of the public not to stamp their feet as the vibration could be dangerous, and in 1880 Parade House was built. The New Ground was once connected to the quay by a bridge, and between the bridge and the Assembly Rooms was the Great Conduit, one of the town's water sources.

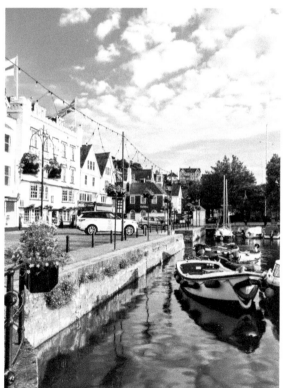

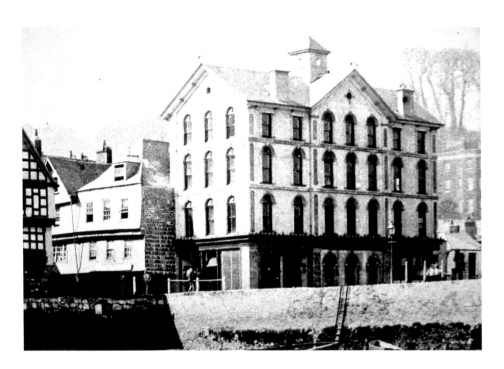

Parade House

The NatWest Bank can trace its history back to the establishment of the Dartmouth Bank in 1795. Although it was located in offices in Duke Street as the National Provincial Bank for most of the nineteenth and twentieth centuries, in the First World War it briefly took over the Parade House premises from the failed Naval Bank. During the Second World War, Parade House lost its top two floors to blast damage from the bomb in Duke Street. Parade House was demolished in 1979 and the growing NatWest Bank moved into new purpose-built premises on the site.

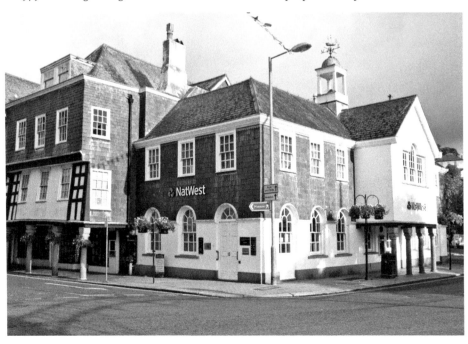

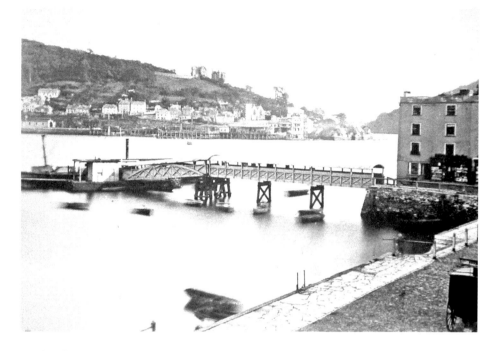

Spithead

The quay was extended to form Spithead in 1585, but tidal mud always made access difficult at low water. Here, pre-1885, we see the pontoon leading to the deeper water off Spithead from where Lloyds Bank is now. By 1893, the pseudo-Tudor Yorke House was built on the corner of the new embankment. Spithead Quay was covered by elaborate paving stones incorporating a compass, dated 1679, and surrounded by a Dutch garden maze of paths and flowerbeds. It was ripped up in 1890 by the Borough Corporation, much to the dismay of the townsfolk.

Lloyds Bank, Spithead

From 1892–1911, Lloyds Bank was located in a cramped single-width building in Fairfax Place. Requiring a location more in the commercial centre of town and near the new South Embankment, Lloyds took a long lease on one of the old buildings on Spithead. By demolishing the old houses and shops, the bank gave Dartmouth an imposing new building with a mock Renaissance-style façade, which is now a Grade II listed building. The Dartmouth Harbour Commission was one of the early tenants in the offices above the bank.

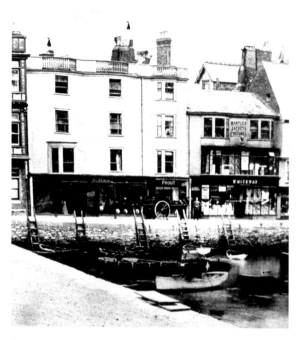

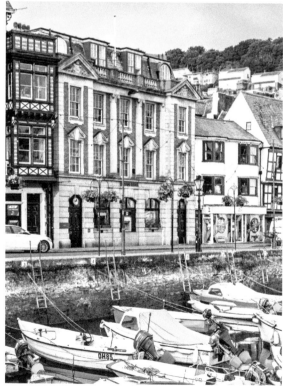

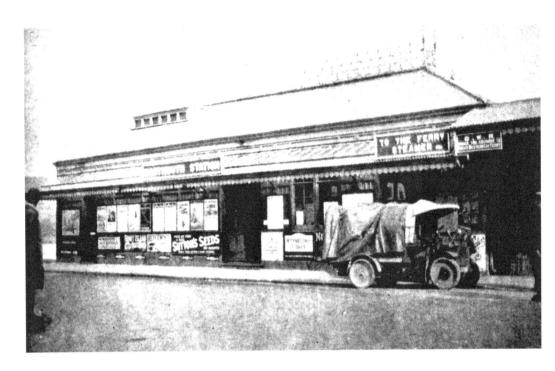

Dartmouth Station

The extension of the Torbay railway to Kingswear was completed in 1864, and Dartmouth station was initially just a floating pontoon and booking office. The station, built in 1889 on the new embankment, is said to be the only station in Britain with no trains. Passengers alighting at Kingswear station would catch the passenger ferry, the *Dolphin*, and later the *Mew*, to Dartmouth station. Steam trains still travel the rail route from Paignton, and the passenger ferry continues to carry foot passengers between the two stations.

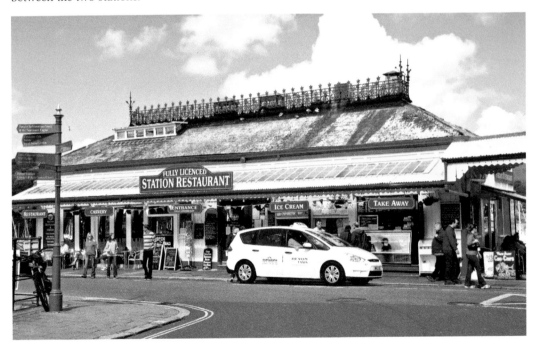

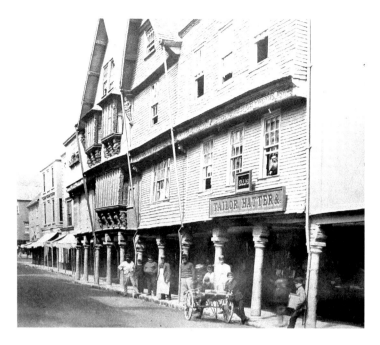

The Butterwalk

The Butterwalk is one of Dartmouth's most iconic sights, with its gables, hanging slate and carved wooden beasts. Built as four merchant's houses in the 1630s, there was access to the quay behind them through a wide passageway. The Butterwalk has a number of decorative plaster ceilings, but one stands out. The 'Tree of Jesse', a patterned plaster ceiling depicting the ancestry of Christ thought to be the only one of its kind in the world, is very distinctive. An elaborate over-mantel plaster of the scene at Pentecost can be enjoyed with a Devon cream tea in the Sloping Deck restaurant.

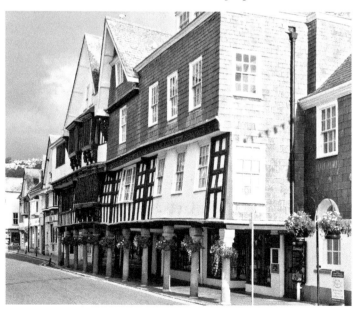

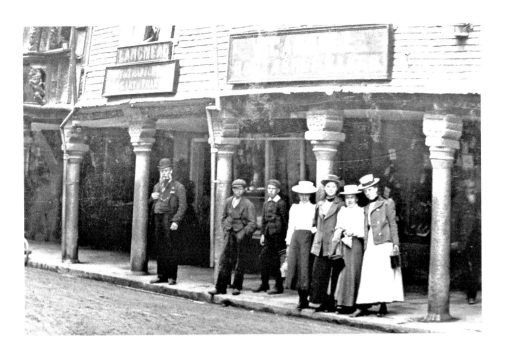

Dartmouth Museum

Housed in one of the merchant's houses of the Butterwalk, Dartmouth Museum is a gem. It is entered up a staircase winding around an old ship's mast. Showcasing Dartmouth's history with a wide variety of material, much of it hands-on, the museum traces Dartmouth's nautical, industrial and social developments. There are examples of Dartmouth pottery, a video loop of the Second World War training at Slapton Sands, and a time capsule of Victorian Dartmouth within the Henley Study. The newly renovated Jesse Room, with its unique Tree of Jesse, is viewed by enquiring at the museum.

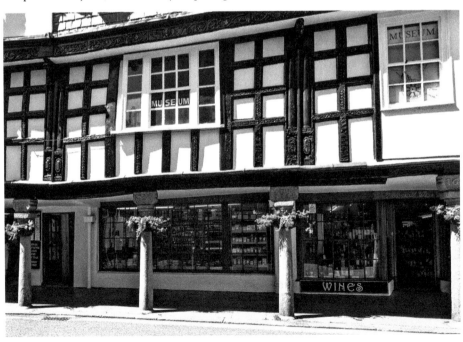

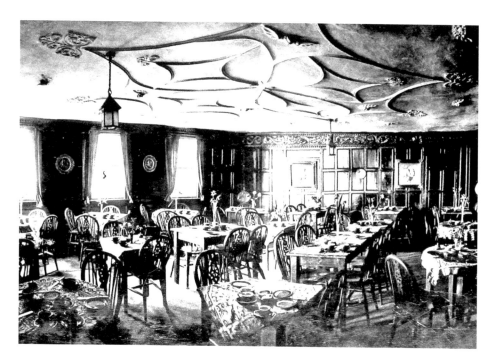

Merrie Monarch Café

Once the Merrie Monarch Café, this front room of the Dartmouth Museum is now called the King's Room. With its wood panelling and plaster ceiling, it was the location used by the mayor to lavishly entertain King Charles II in 1671, when his yacht was forced to shelter in Dartmouth due to bad weather. The room now traces Dartmouth's maritime history, from the Crusades to D-Day, through stories of the people and models of their ships. The king's crest over the fireplace is a reminder of the royal visitor.

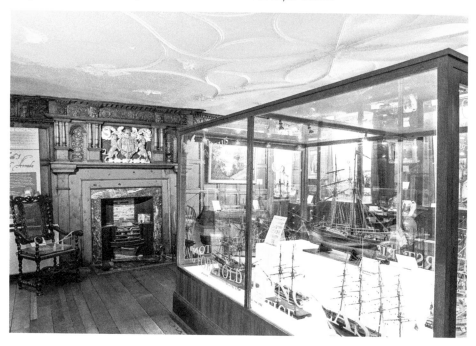

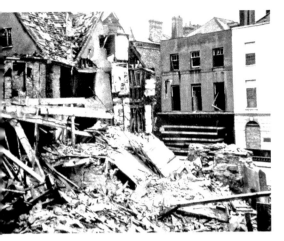
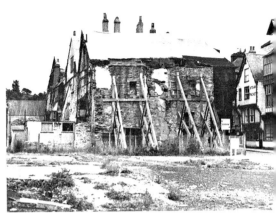

Bomb Damage in Duke Street

On Saturday morning, 13 February 1943, two German bombs struck the town centre. One landed in Higher Street, narrowly missing the primary school, but destroying the Town Arms pub. It killed the grocer's wife and daughter next door, along with the delivery boy in School Steps. In Duke Street another bomb hit the Midland Bank (now HSBC), bringing the total death toll to fourteen. Buildings on both Duke Street and Foss Street collapsed, while the Butterwalk was severely damaged (*above*), and Parade House lost its top two floors. On the opposite side of Duke Street, Ernest Hawke's and the National Provincial Bank (now an estate agent's) were damaged but remained standing.

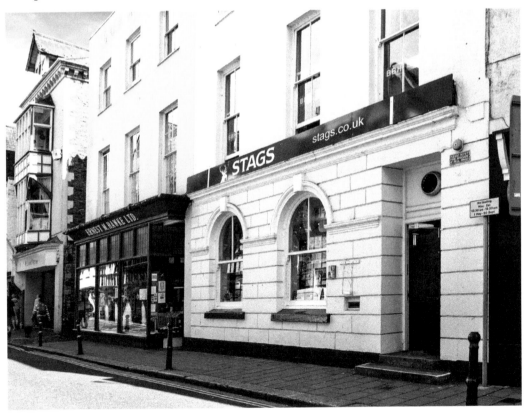

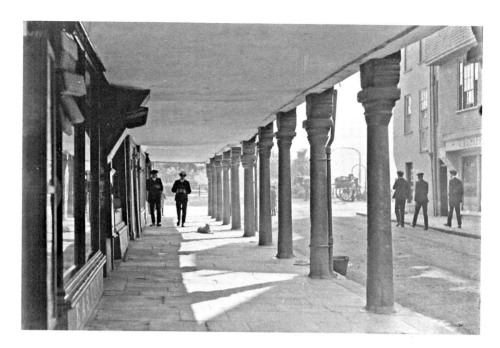

Saving the Butterwalk

The Butterwalk was so badly damaged by the 1943 bomb that many feared it would have to be pulled down. Although the plasterwork had been carefully removed and the building shored up, Dartmouth Corporation's procrastination meant it was badly neglected for a number of years. It was in danger of collapsing and becoming lost to the town. Fortunately, Whitehall sanctioned the first post-war grant in the country to repair a war damaged building, and in 1954, the grand opening of the restored Butterwalk took place. The Butterwalk of today, therefore, differs little from the Butterwalk of the early twentieth century (*above*).

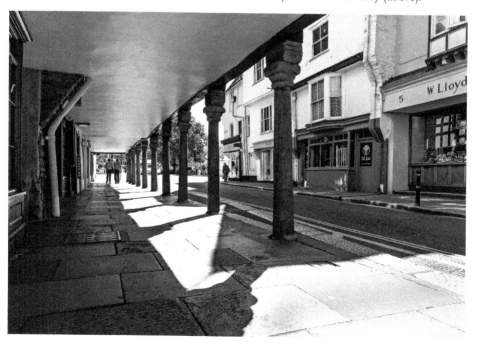

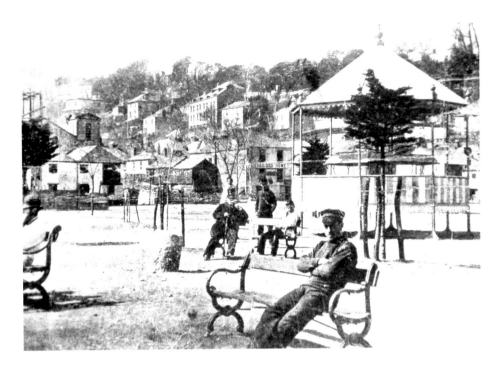

The New Ground

Land reclamation of the New Ground began in around 1670, to provide extra quay space for ships. Too unstable to build on, it soon began to be used for recreation, including Guy Fawkes Day bonfires and fairgrounds. To commemorate Queen Victoria's Golden Jubilee in 1887, the New Ground became Royal Avenue Gardens. Still well used, the gardens provide the venue for regatta ceremonies, Remembrance Day, music and food festivals, fêtes and performances throughout the year.

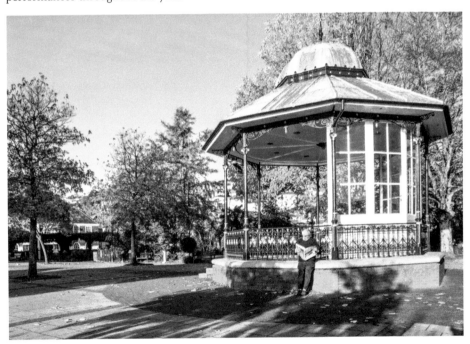

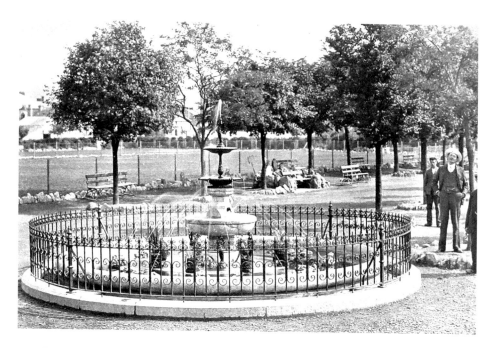

Royal Avenue Gardens

Installed in 2012 by the Old Dartmouthians Association, the current fountain commemorates the Diamond Jubilee of Queen Elizabeth II. The original fountain (*pictured above in 1905*), with a base made from builder's rubble costing only £21, marked Queen Victoria's 1887 Golden Jubilee. In 1992, a new archway was made by local blacksmith Alan Middleton, whose family were involved in making the first arch in 1860, which held gas lanterns. South Hams District Council now maintains the gardens, which are a focal point for the annual Britain in Bloom competition in which Dartmouth has had consistent success.

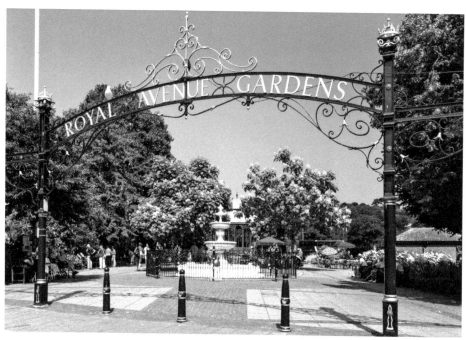

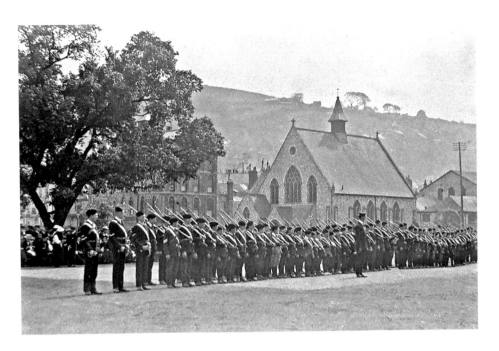

Flavel Church and Tourist Information Centre

A gifted Puritan preacher and writer, John Flavel became vicar of St Clement's church in 1656. After Charles II returned to the throne, hostility to Puritans meant Flavel had to preach in secret. Later, a meeting house was set up in Foss Street, and the Flavel church (now a United Reformed and Methodist Partnership) was built in Mayor's Avenue in 1896. Opposite the Flavel church is the tourist information centre, housing one of Thomas Newcomen's original atmospheric engines, which is still in working order. The parade ground (*above*) is now the car park.

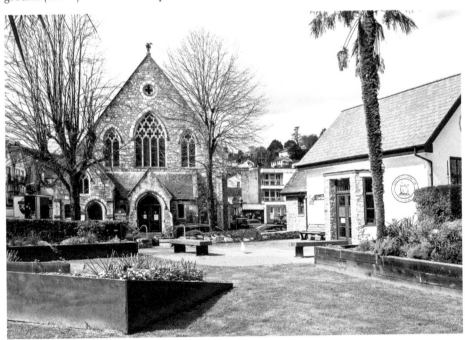

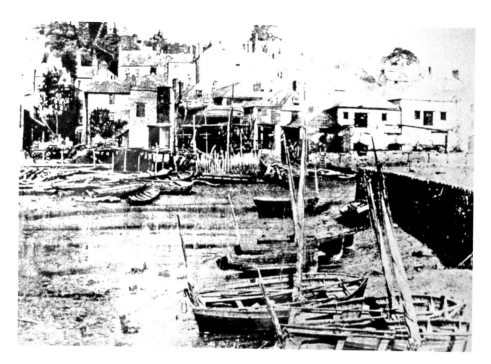

The Pool

Isolated by the construction of the New Ground in 1684, the tidal pool bordering the edge of Hardness was lined with shipyards. By 1877, the pool was 'pervaded by an abominable stink' and considered a serious health hazard. Using rubble from the demolished buildings, the pool was gradually filled in, and the present Mayor's Avenue built on the reclaimed land. In 1871 the landlord of the George and Dragon Inn was summoned for allowing games of cards to be played in his public house.

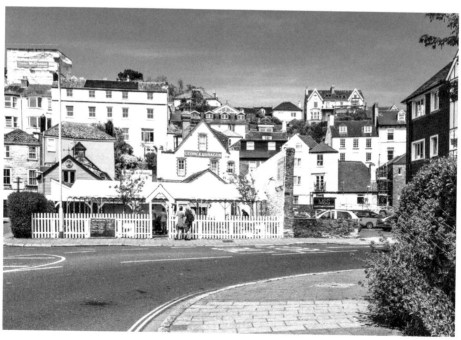

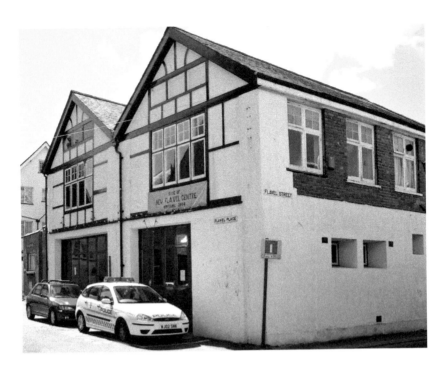

The Flavel Arts Centre

After years of community fundraising, the new arts centre opened in 2005 in Mayor's Avenue. The Flavel replaced the old fire station (*above*), which had moved to College Way, and the second Flavel church hall next to it. Housing Dartmouth's library, an auditorium with retractable seating, meeting rooms, exhibition space and a café, The Flavel has become the place to go in Dartmouth for entertainment.

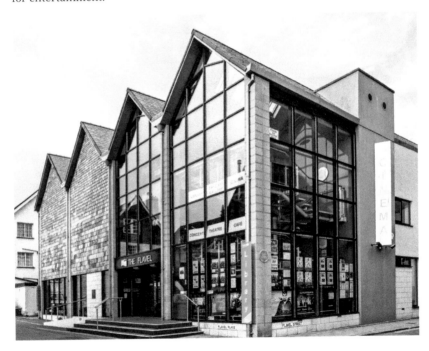

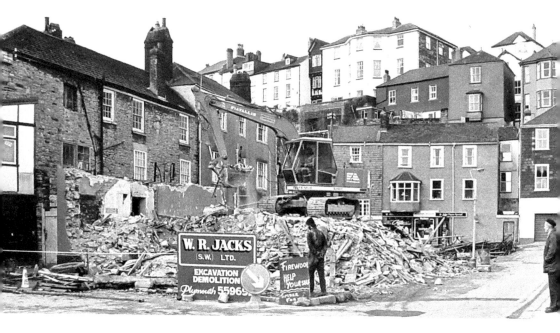

Zion Place

For many years, the cinema on the corner of Zion Place and Mayor's Avenue was one of the few entertainments in the town. Although demolished in 1986 in order to provide a place for the new clinic, it wasn't until 2005, when The Flavel opened, that the town once again had regular films. The building on the left was a quayside warehouse and it later became a bonded store and, more recently, a sail loft and yacht rigging workshop. Mount Galpin House, home of the Holdsworth family (who were influential in the town between 1715 and 1832), looks down on the former pool from Clarence Hill.

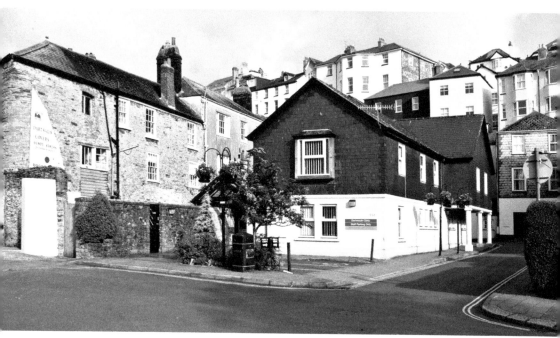

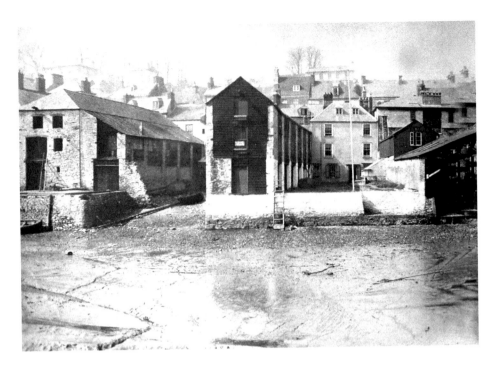

Mayor's Avenue

Some of the only buildings remaining today that were standing when Mayor's Avenue was the Pool at Hardness, are shown here in 1860 at low tide. The old quayside warehouse (*above*) became part of Hawkes Coal Merchant, and now provides storage and shop space for Travis Perkins. The ropewalk, with the house behind on the right, has recently been modernised and now provides small shops and housing.

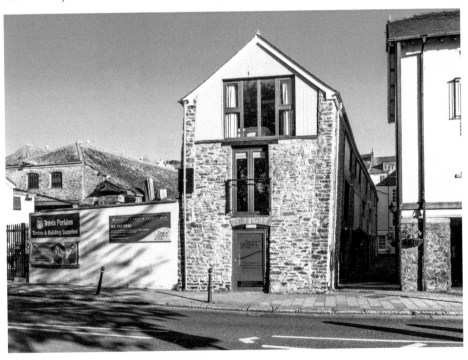

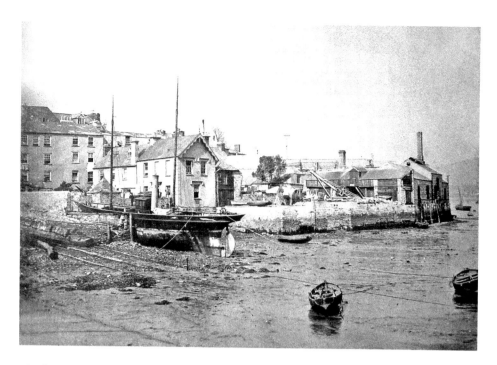

King's Quay

Francis Simpson, a marine engineer, set up a boat building business at King's Quay in 1873. He built fast steam launches and yachts, which used new and more efficient steam engines. He opposed the embankment scheme because it would cut off his business from the river. Eventually, with the filling in of the pool, he moved the firm to Sandquay. In 1891, with his new partner, the firm of Simpson, Strickland & Co moved to Noss Point. When the firm went bankrupt in 1916, the works were bought by Philip and Son.

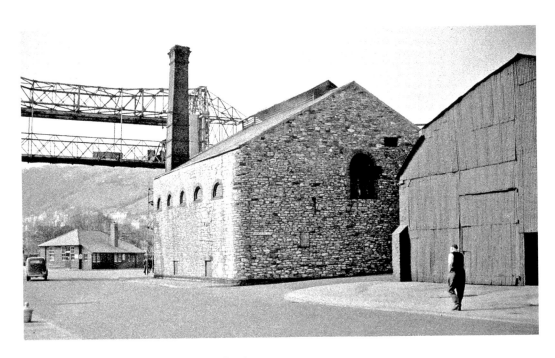

Corner of Mayor's Avenue and the Embankment

The coal bunkering trade, an important part of Dartmouth's economy in the nineteenth century, finally came to an end after 100 years when oil replaced coal for ships' engines. No longer needed by the lumpers, the coal lumpers' rest at the corner of Mayor's Avenue and the Embankment became the site of the clinic, now just a grassy area. The overhead coal conveyor was erected in 1931 to supply the gas works behind Mayor's Avenue with gas and coal, which was unloaded in Kingswear and transported across the river to the conveyor in barges, until that, too, ended in 1962.

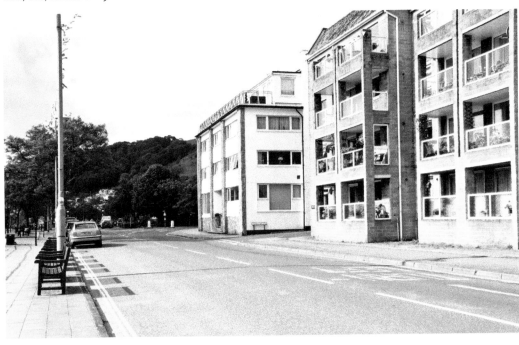

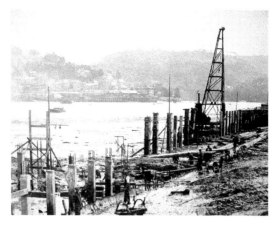

Constructing the North Embankment

In the mid-1920s, more and more people were arriving on holiday in Dartmouth by car, creating early concerns about managing traffic that continue to this day. The 1928 solution was the Coombe Improvement Scheme, designed to move traffic more easily to and from the Higher Ferry by extending the South Embankment 312 yards across Coombe Mud to the Floating Bridge. It would also give Dartmouth a much needed recreation area on the reclaimed mud when finally completed in 1937. Note how the embankment was built as a bridge, walled on both the river and landward sides.

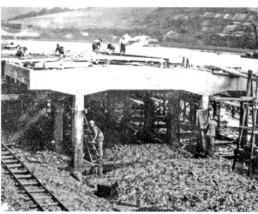

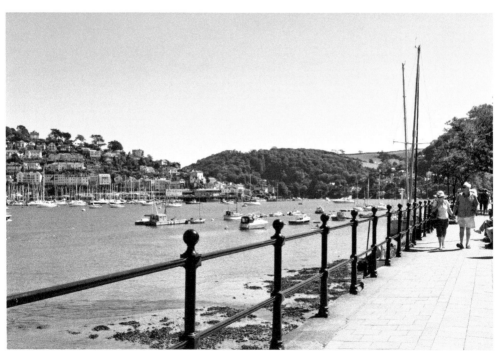

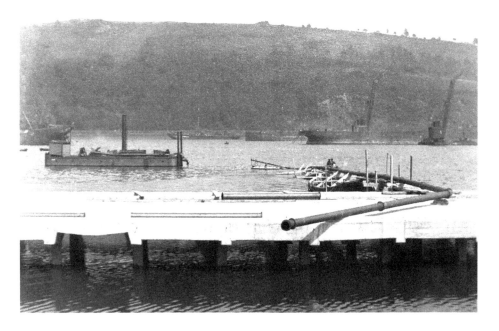

Rue de Courseulles sur Mer

The differences between the North Embankment of the 1930s (when it was being constructed) and the current view of the same place on the far bank (*below*), depict the changes that have occured on the river in the last centruy. Today, the embankment has a wide pavement, giving better pedestrian access to the many visitors who stroll along it. Pleasure craft fill the available pontoons and moorings. Commercial use of the river is now mainly fishing and tourist boat trips. The North Embankment gained its French name to commemorate the town's 1977 twinning with Courseulles sur Mer in Normandy.

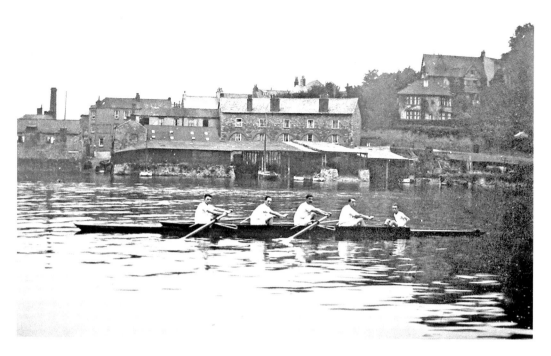

Coombe Mud

Before the North Embankment was built, enclosing Coronation Park, Coombe Mud flooded with the tide, as seen here in 1933. Newcomen Cottage is visible (*top right*), but the boatbuilding yards and buildings behind, once located on the water's edge, have all gone, replaced by today's RNLI station. There was a lifeboat station in Dartmouth from 1878 to 1896, located at Sandquay, but in eighteen years the lifeboat only launched three times. In 2007 Dartmouth once again gained a lifeboat, and the D-class inshore rib, *Spirit of the Dart*, has averaged thirty launches per year since then.

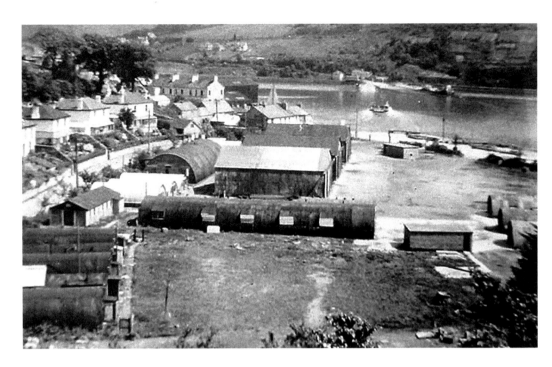

Coronation Park

The recreation area was officially opened in 1937 and named Coronation Park to mark the Coronation of King George VI, formerly a cadet at BRNC. In 1944, the US military filled the park with Nissen huts using the newly grassed park to repair landing craft damaged in exercises, which would be needed for the invasion of France. Still buried beneath the park are the remains of a German destroyer and British submarine, both from the First World War. The submarine was used by local children as a play area until one became trapped in the 1920s, after which it was cut up to avoid further tragedy.

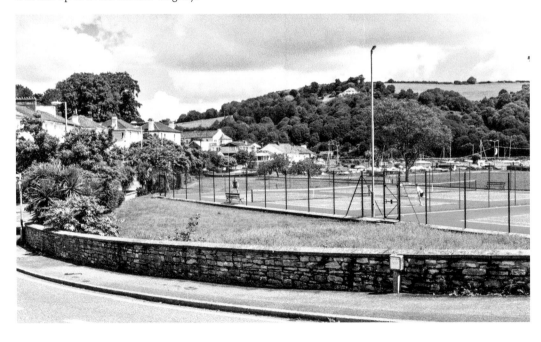

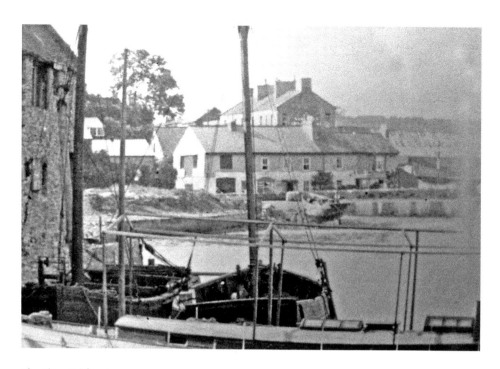

Floating Bridge Inn

Without the North Embankment and with no College Way, the only access to the Higher Ferry was behind the boatyards to the Floating Bridge Inn. When Coombe Mud was filled in after the completion of the North Embankment in 1937, for the first time in 700 years there were no shipyards on either side of the Hardness shore from what is now Mayor's Avenue around to the Floating Bridge. Now The Floaters (the local nickname of the pub) overlooks only sailing dinghies stored in Coronation Park.

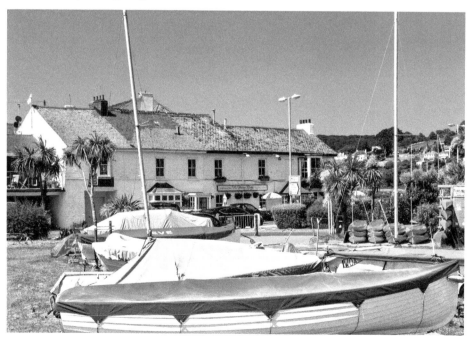

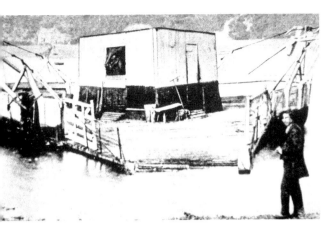

The Higher Ferry

The Dartmouth Floating Bridge opened in 1831 to the sound of bands playing and people cheering. Sixty carriages (four at a time), along with 200 saddle horses and hundreds of pedestrians, crossed the river. In the years since, there have been eight floating bridges running on chains between Sandquay and Lower Noss Point. The second ferry (*above left*) was powered by two horses working a treadmill in the centre of the ferry. The third ferry (*above left*), built locally by Philip and Son Ltd, was steam powered. The newest, which arrived in 2009, again to cheering crowds, carries thirty-two cars and has simultaneous loading and unloading.

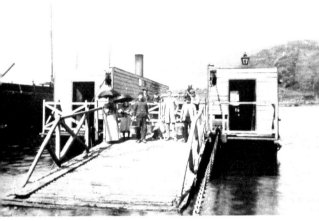

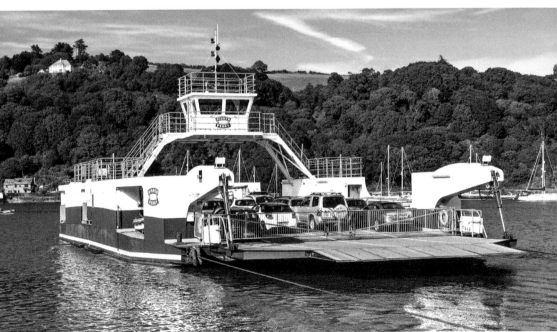

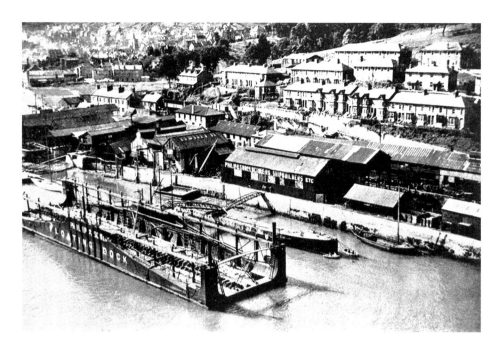

Coombe, Sandquay

Shipyards had already been at Coombe for fifty years when George Philip, a Scotsman, came to Dartmouth in 1843 as a foreman. George and his son took over all three shipyards there in 1891, and twenty-five years later also acquired the bankrupt Simpson, Strickland yard at Noss. The floating dock arrived in 1924, first used at Noss before being moved to Sandquay, and finally towed away for scrap in 1961. Nearly 1,500 vessels were built by Philip's, including thirty-five lightships, but shipbuilding and repair ceased at Noss in 1999. The main business at Sandquay today is the hotel, marina and apartments.

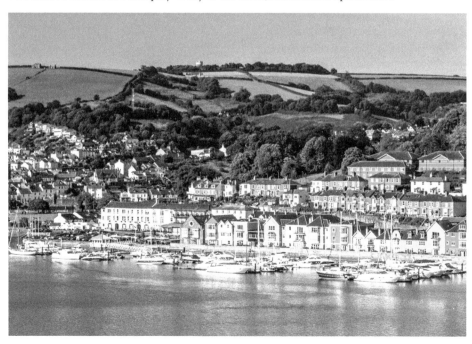

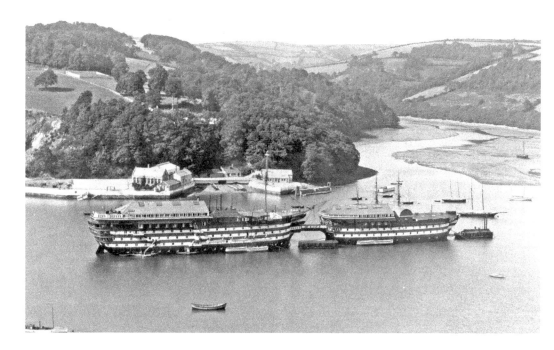

HMS *Britannia* and *Hindostan*

The first *Britannia* (the fourth to have this name) came to Dartmouth in 1863, welcomed by the ringing of church bells and beginning Dartmouth's long and continuous association with naval training. Overcrowding soon led to the addition of the *Hindostan*, which was joined to *Britannia* by a covered walkway. In 1869, a larger *Britannia* replaced the original, remaining in the river until she was finally towed away in 1916. Over 5,000 cadets trained in the ships while they were moored in the River Dart off Sandquay.

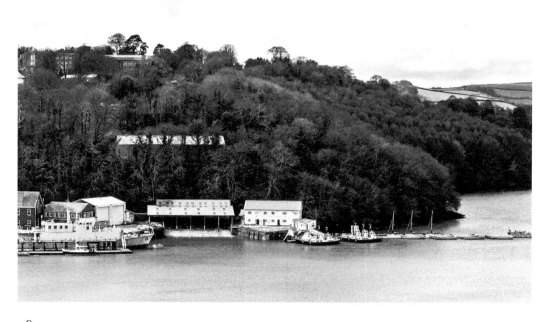

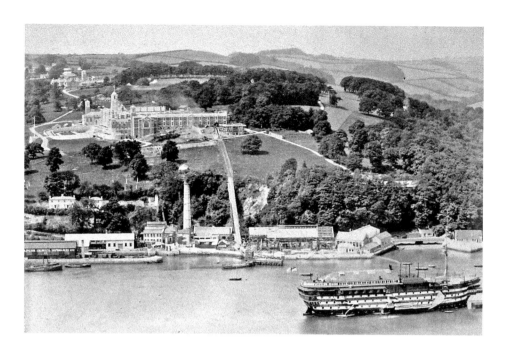

Britannia Royal Naval College

Although Sir Aston Webb's Edwardian masterpiece has overlooked the town since 1905, Dartmouth had to compete with thirty-two other sites for the onshore college. The health of the cadets was a major concern, but Mount Boone Park, on the hill above Sandquay, met all the criteria. It had good drainage, a source of pure water and sewage could drain into the River Dart (which it did until near the end of the twentieth century). There was ample space for exercise and a few 'special temptations' in Dartmouth. Building began with the sunken garden, which is now the parade ground. The inclined plane was used to take materials from Sandquay to the building site.

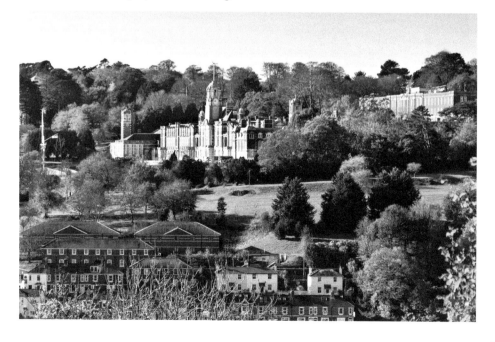

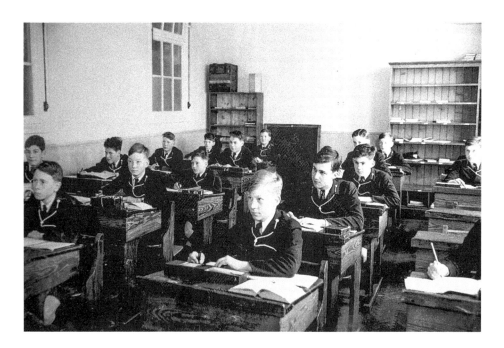

Training at BRNC

In the 1800s, cadets passed an entrance exam and entered naval training at Dartmouth aged twelve, receiving a similar education to that of other public schools. The ship's bell was rung every half-hour. The boys slept in hammocks and were also taught navigation, seamanship and naval history. Now, the average age of entry is twenty-four, three-quarters have university degrees, women have been included since 1973, and officer cadets are trained in subjects including Meteorology, Oceanography, Strategic Studies, Maritime Leadership, Marine Environment and Ship Technology.

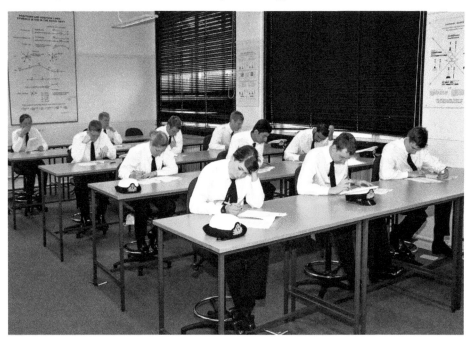

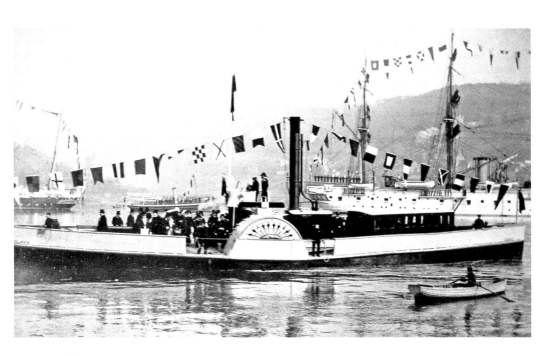

Royalty Comes to BRNC

BRNC's long connection with the royal family began in 1877, when the Prince of Wales made the decision to send both his sons to the establishment. He returned on board *Dolphin* (*above*) in 1902 as King Edward VII to lay the foundation stone at the college. Over the years, many royal sons have attended BRNC, Prince William being the most recent to sign his autograph on the ward room ceiling. The Queen met Prince Philip when he was a cadet and she was visiting with her parents in 1939. Since 1970, the Queen or her representative have taken the salute at the annual Lord High Admiral's Divisions, as HRH Princess Anne did in December 2012.

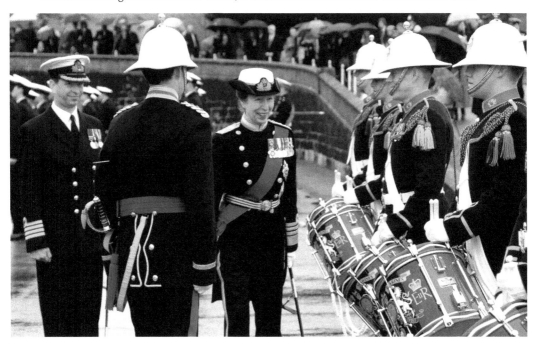

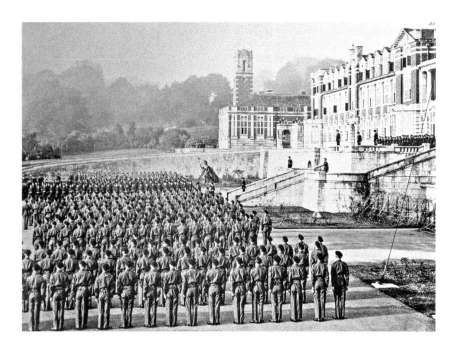

War and BRNC

During summer leave in September 1942, the college was hit by two bombs, causing substantial damage and one fatality. Following the bombing, the juniors were moved to Bristol. A year later, the entire college was established at Eaton Hall, Cheshire, for the remainder of the war. Meanwhile, the college premises, renamed HMS *Effingham*, were taken over by combined operations for training Royal Marines, and later by American forces during preparations for the D-Day invasion. The figurehead of *Britannia* was painted in camouflage, and barbed wire surrounds the parade ground in the Divisions Parade, 1943.

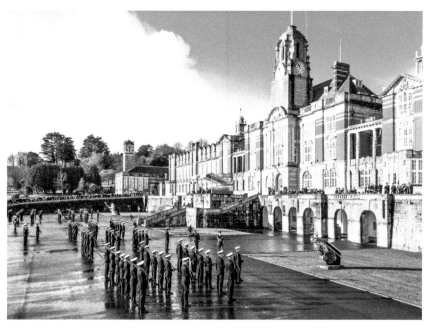

BRNC's Entrance Gate

In the years after the college opened, there was an increasing need for naval officers. In 1917, D block rose above the skyline of the original buildings, but the most visually obvious change has been to the college entrance. With the building of College Way in 1969, the original gatehouse on the west side of Coombe Mud was demolished and the entrance was moved up the hill. Following the demolition of the old gatehouse, the Sea Cadets occupied a hut near the site for many years before moving into premises in the college itself during the 1990s.

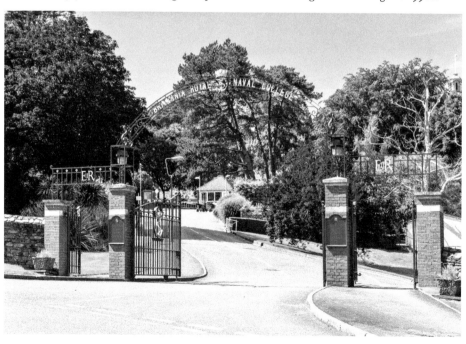

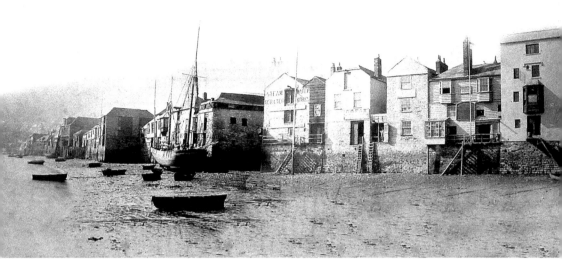

The South Embankment

Before the South Embankment was built in 1885, ships could moor by the warehouses at high tide. When the tide was out, they sat in the mud. The Dartmouth Harbour Commission's plan to build an embankment created bitter hostility and split the town for a number of years. A decade of lawsuits that nearly reached the House of Lords, only ended when the Harbour Commission went bankrupt. Over the years since completion, the new land that the Embankment created has proved a great asset to the town.

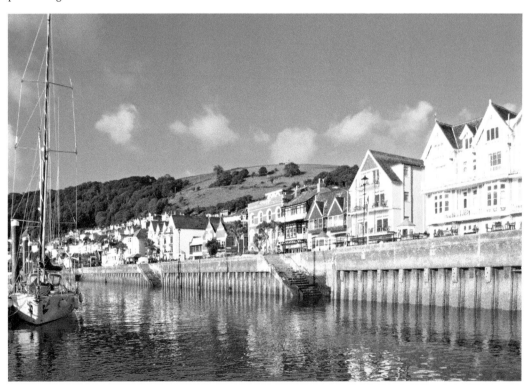

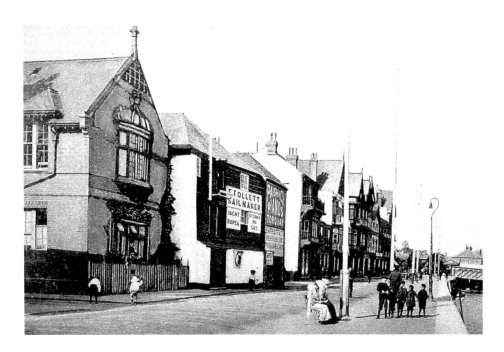

Dartmouth Cottage Hospital

The first hospital in Dartmouth was built by Dr Puddicombe in his garden at Southtown in 1873; the second was in Bayards Cove for seven years from 1887. Finally, in 1894, a new purpose-built hospital opened on the South Embankment, paid for by public subscription. Queen Victoria gave a donation of £20 to the hospital in June 1900, when it treated four petty officers injured in a firework display on the royal yacht in the harbour. In 1909, the drugs and dressings bill for treating forty-eight patients was £12 0s 10d. Extended in 1926, with further additions in 1974 and 1982, it is now a sixteen-bed community hospital.

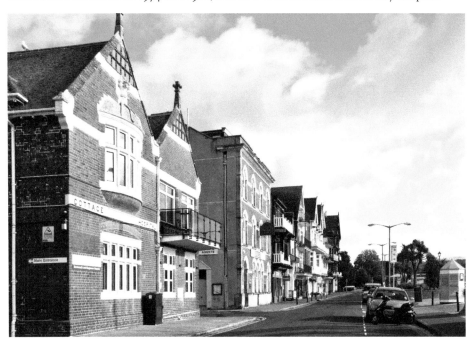

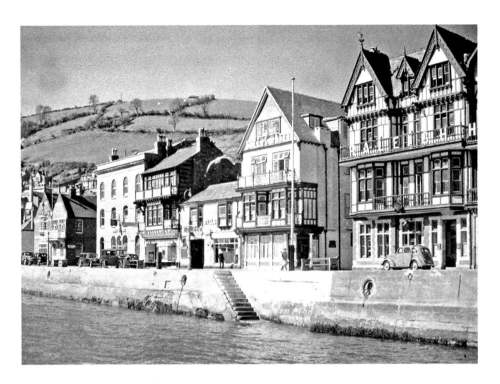

Raleigh Temperance Hotel

The first of the imposing buildings to be built on the new South Embankment in 1889 was the Raleigh Temperance Hotel (*above*), built at a cost of £1,800. Its ground floor housed the post office until 1907 when it moved to a new purpose-built establishment further along the South Embankment, on the corner of Hauley Road.

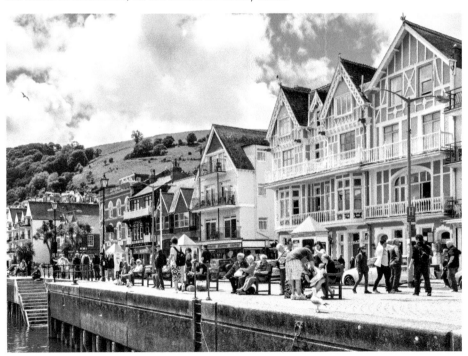

Fishing on the South Embankment
Dartmouth and Kingswear still have
small crabbing fleets, but gone are
the days of landing huge shipments
of fish on the quay. Instead,
dangling a line into the River Dart
is a more common sight along the
embankment, and has always been
a popular activity with the children
of Dartmouth. Every year during
Dartmouth Royal Regatta, children
pull hundreds of small crabs out
of the water in the crab fishing
competition, only to dump them back
in afterwards.

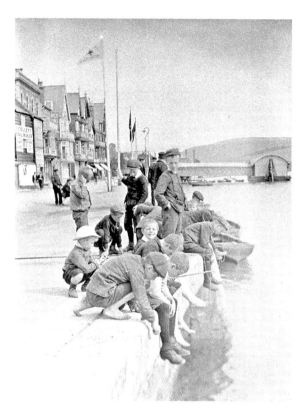

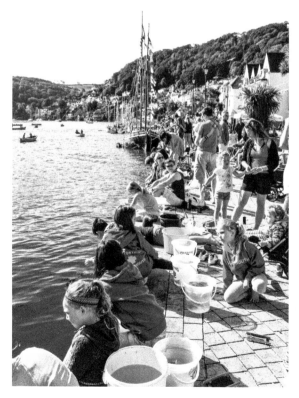

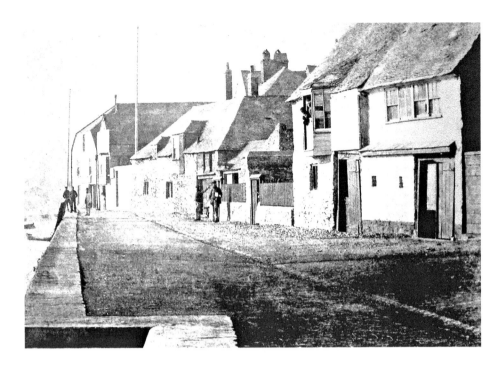

Tipper's Quay

With the exception of Tipper's Quay at the end, the buildings on the southern part of the South Embankment are now quite different to the ones on the embankment when it was newly built. The Channel Coal Company and Renwick-Wilton, both bunkering businesses, had premises built on the new Embankment in what is now the Dartmouth Yacht Club and the restaurant next door. In the mid-1980s, the South Embankment was widened and the 100-year-old crumbling walls replaced, adding 6 metres to the width and raising the edge to prevent flooding at high spring tides.

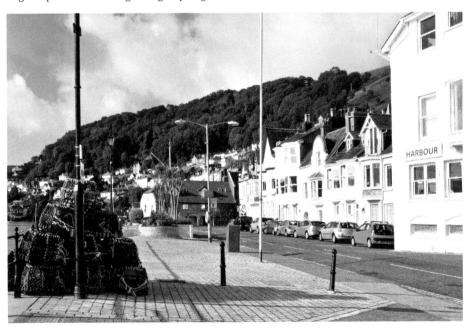

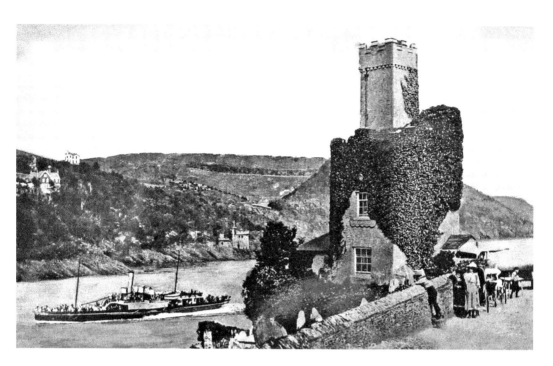

Tourism on the River

Visitors have long enjoyed walking out to the castle or getting the *Castle Ferry* to the steps by St Petrox to have a cream tea at the Castle Tea Rooms. A trip to Totnes by paddle steamer or river boat, or a steam train ride to Paignton, have been attractions for over a century. Always popular with the Torbay tourists is a trip to Dartmouth in the *Fairmile* (*below*), a restored Second World War motor cruiser, now repainted in her wartime colours. *Fairmile* also offers trips to Slapton Sands, site of the American training for D-Day and memorial to Exercise Tiger with its disastrous loss of life.

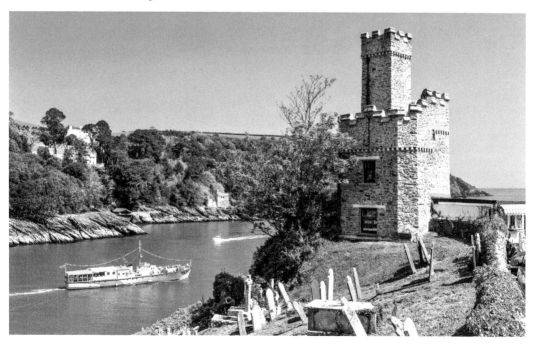

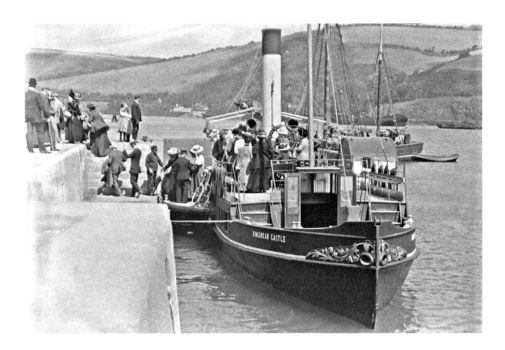

Paddle Steamer Kingswear Castle

The first *Kingswear Castle* to ply the river was built in 1904 in Falmouth. She was stripped of her engine, sold, and in 1924, became an isolation hospital moored in the river – later to be burned out and left as a hulk on the riverbank near Totnes. The engine of the first *Kingswear Castle* now powers the current *Kingswear Castle*, built in 1924 by Philip & Son. She was used by the US Navy as a harbour tender during the Second World War, and remained in service on the Dart until 1965. Restored by the Paddle Steamer Preservation Society, she provided river trips on the Medway until her return to the River Dart in 2013. She is now the only coal-fired paddle steamer still in operation in Britain.

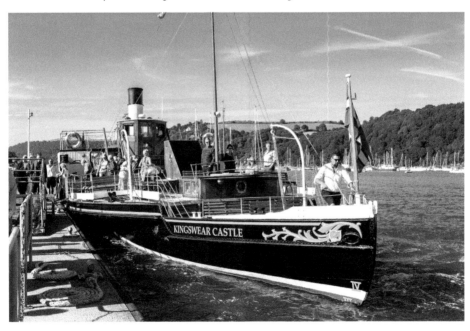

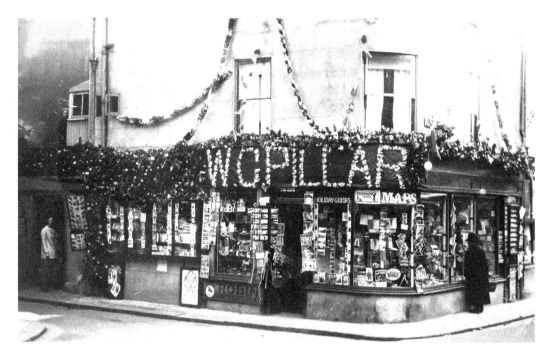

W. G. Pillar, Newsagents

Dartmouth Grenadier Guardsman William George Pillar was only eighteen when he lost a leg in the fierce fighting at Passchendaele in Autumn 1917. With the help of his mother and sister, he opened a small newsagent's and sweet shop at No. 2 Lower Street in 1919. It was later moved next door to the more spacious corner premises and for a number of years also contained a lending library. Still run by the family, Pillar's is one of the oldest surviving family businesses in Dartmouth. Like all local businesses, W. G. Pillar's was decorated for Carnival in the summer of 1929.

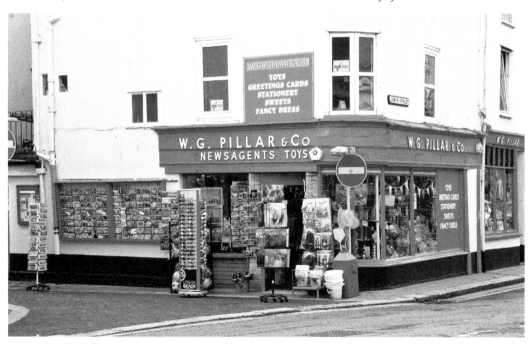

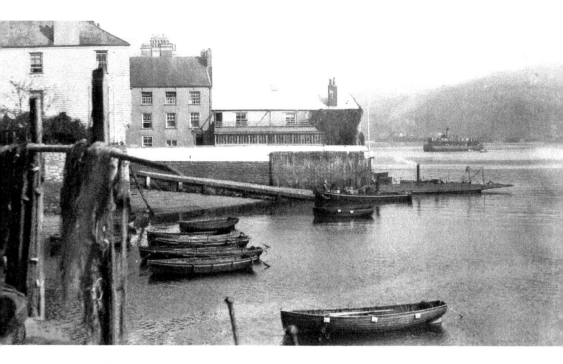

Lower Ferry Slip at Bayards Cove

Bearscove (as Bayards Cove was then known) has probably been the landing point for a ferry from Kingswear since at least 1365. The Pulling Ferry, as it was called, was rowed by a single oarsman in the early days. With the need to get horse-drawn vehicles across the river, a float was introduced, rowed by two men. This service became known as the Horse Ferry. Steam tugs began to power the Lower Ferry float in 1867. *Relief*, the steam tug with the float (*above*), began service in 1915.

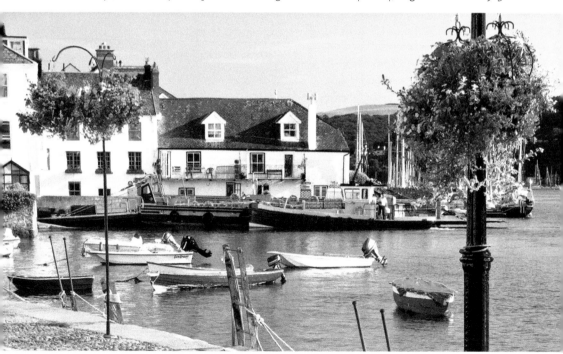

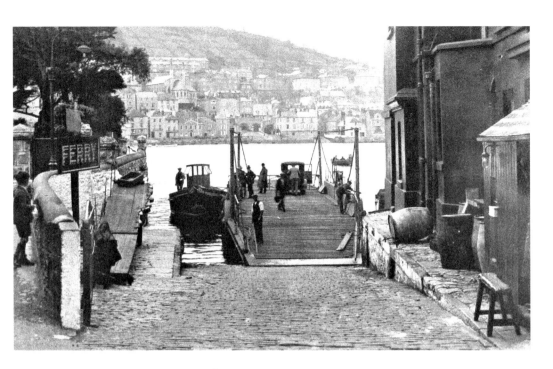

The Lower Ferry at Kingswear Slip

Owned by the railway company since 1864, but leased first to Mr Avis, the local postmaster, and later to the Casey family for fifty years, the Lower Ferry was bought by Dartmouth Corporation in 1926 for £100. In the 1950s, the Lower Ferry ceased running passenger launches, but the floats like *Big Jumbo* (shown *above in 1929*) and *Tom Casey* (*below*) are still pushed and pulled by tugs named *Hauley*. The Lower Ferry is now owned and run by South Hams District Council.

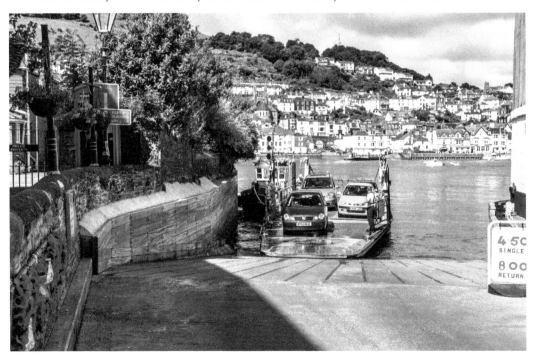

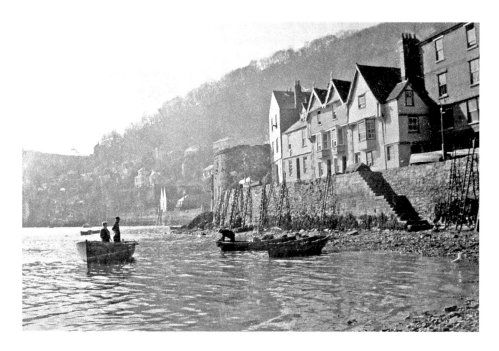

Bayards Fort

Built by Dartmouth Corporation in around 1530 with a grant of £40 per year from the king for construction and maintenance of fortifications, the new fort at Bayards Cove was to serve as an artillery battery to protect the harbour. The eleven gun ports were constructed just at a time when artillery was changing from static to wheeled cannon, so the fort's design made it obsolete not long after completion. However, it did form part of the town's defences in the Civil War, although the guns were only ever fired to mark special occasions, such as coronations or visiting dignitaries.

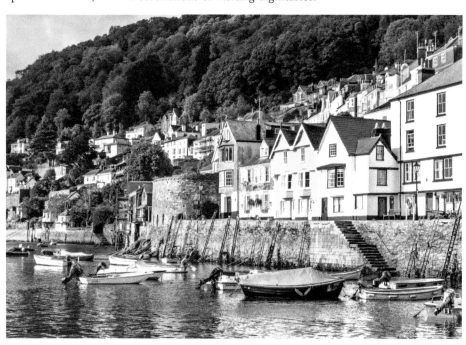

Bayards Cove

Portview House (*right*) probably stands on its own foundations built on the foreshore of the cove in the late 1500s. The quay was built up over the centuries, with major renovations in 1665 and 1839. The guns mounted on the quay are a recent addition, having originally served as the armament for the mock fort in the Seale family's pleasure ground along Old Mill Creek from 1791. The barometer mounted on the north wall of neighbouring Holset House was presented to the mariners of Dartmouth in 1860. In the 1970s, the quay became the set for the nineteenth-century port of Liverpool when filming the *Onedin Line* television series.

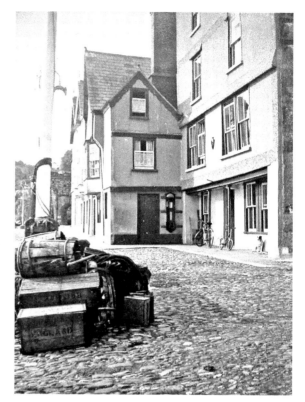

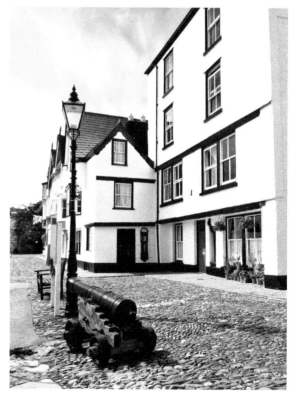

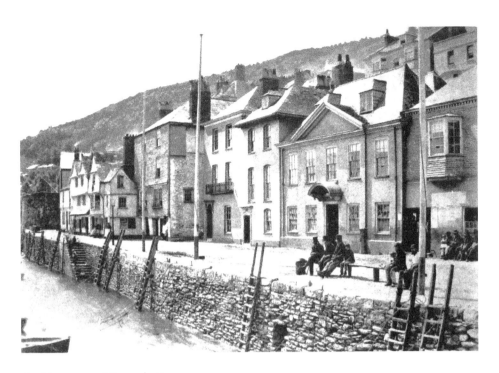

Coal Lumpers at Bayards Cove

Coal bunkering was a major industry in Dartmouth in the late 1800s, creating a noisy and busy harbour with 747 ships bunkered in the port in 1890. The coal lumpers worked in gangs, waiting on the benches at Bayards Cove. The first man with his leg over the ladder on the wall won the job of mooring the ship, and a race in gigs to the lighters gave the winning gang the job of loading. Behind the coal lumpers is the Customs House, built in 1739 by John Seale. It remained leased to the Commissioners of Customs until 1985.

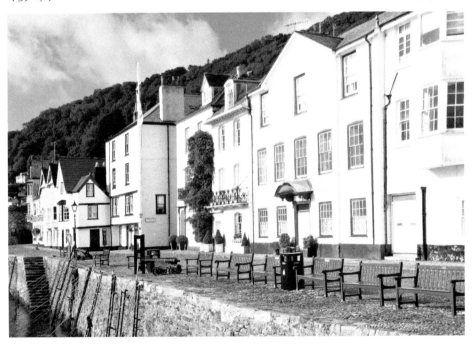

Bayards Cove Cottage Hospital
Dating from the 1820s, Morocco House, with a name probably referring to a connection with the Morocco Shipping Line, was once the home of the Dartmouth Coaling Company. Better known, however, is its role as Dartmouth Cottage Hospital between 1887 and 1894. It was established to celebrate Queen Victoria's Golden Jubilee. Local politics were involved, as a rival Jubilee scheme to renovate the New Ground was also proposed. In the end, both projects succeeded. The slightly older Mission House next door was once the Bayards Cove Mission to Seamen, providing shelter and recreation to the coal lumpers waiting on the quay for work.

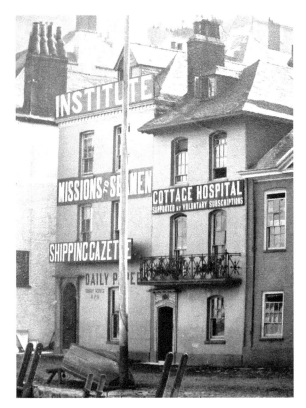

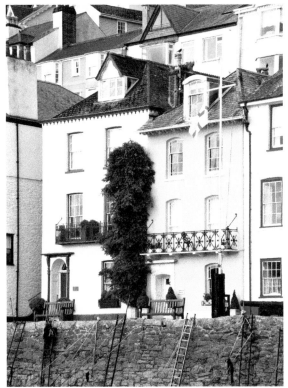

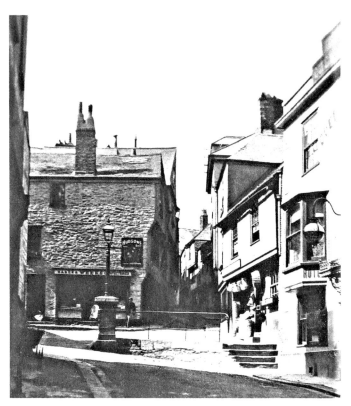

Pillory Square

Here, at the junction of Smith Street with Higher Street, was the centre of the medieval township of Clifton. The foundations of the current buildings are thought to have been laid down in 1308. There were wealthy merchant's houses, as well as many shops, a market, breweries, bakers, butchers and craftsmen. Most important for maintaining honest trading, the pillory and stocks were located here, close to where the lamp post stands in the older photograph.

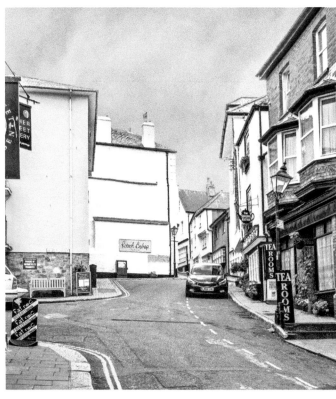

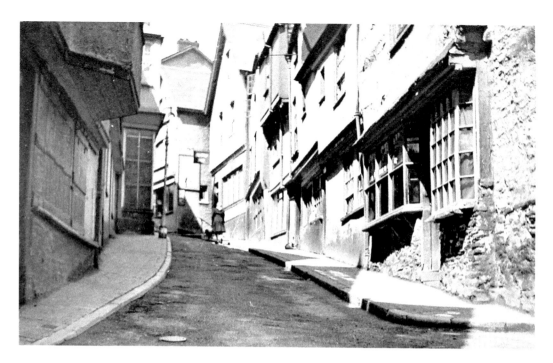

Smith Street

At a time when many roads were known as King's Way, Smith Street was called King's Way From The Sea, leading uphill from Lower Street (which was called King's Way Next To The Sea). One of the craftsmen here in Smith Street was the goldsmith, who gave his name to the street in 1310. The first shop on the left, with its carved wheat sheaves, was once a bakery. Smith Street leads to South Ford Road, following the south side of the medieval inlet to Ford Cross.

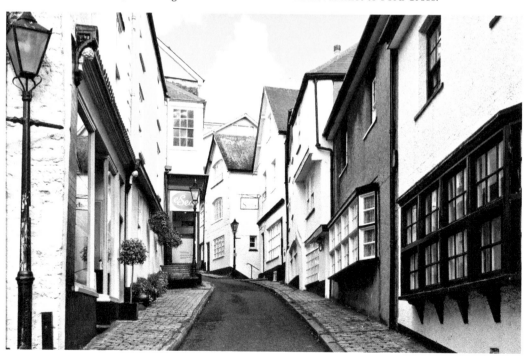

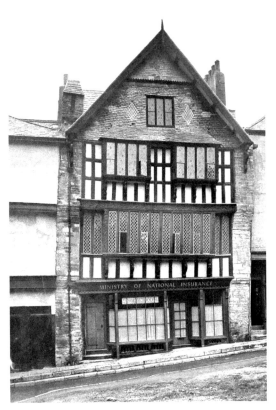

The Fire of 2010

On 28 May 2010, a devastating fire ripped through the four buildings on the corner between Fairfax Place and Higher Street. Eighty firefighters fought the blaze with two high ladder appliances. It took three years of planning and restoration work, but all the buildings are now once again back in use, their medieval features restored. An important listed building, known as The Tudor House (but misnamed as it dates from 1640), has a Jacobean moulded plaster ceiling, leaded windows and wood panelling. It has housed several different restaurants and the Job Centre, and is now the café home of Radio Dart.

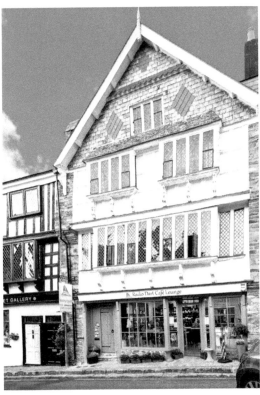

The Cherub

Higher Street was lined with fourteenth-century houses, their top floors overhanging the street until 1925 when many were demolished. The Cherub pub, thought to date from 1380 and therefore qualifying as the oldest building in Dartmouth, is renowned for its floral displays. With plaster covering its half-timbering, it was condemned for demolition before being rescued and renovated in 1958. It was then a gentleman's club, before becoming a pub and restaurant in the 1970s.

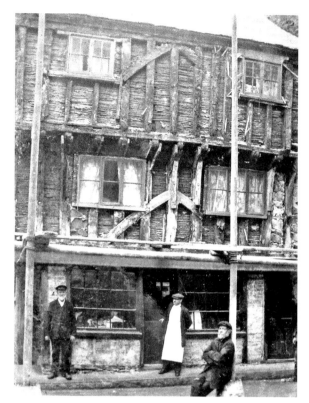

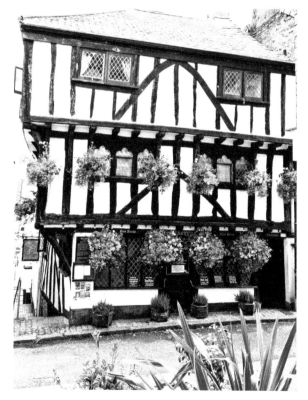

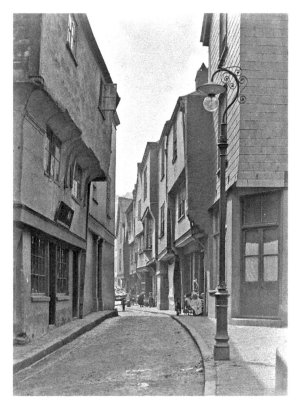

The Community Bookshop

Opposite the Cherub is the Dartmouth Community Bookshop, which opened in 2011 in Higher Street as a not-for-profit community co-operative, following the closure of the Harbour Bookshop in Lower Street after sixty years. Started by Christopher Robin Milne, friend of Winnie the Pooh in his father A. A. Milne's books, the Harbour Bookshop was a long-time feature of Dartmouth commercial life. It was run by Christopher until his retirement in 1983. The community bookshop maintains the connection to the famous characters with its 'Pooh Corner' consisting of books and prints.

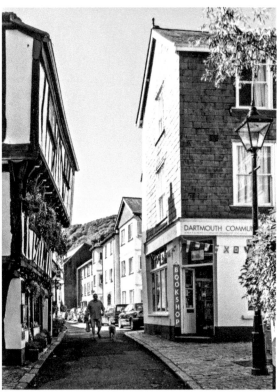

Crowthers Hill

The packhorse route out of
Dartmouth, on the south side of the
valley, was up Crow Tor or Crowders
Hill to Waterpool Lane. In 1627,
following the outbreak of plague,
the mayor ordered the building
of two communal 'pest houses' up
Crowthers Hill in order to isolate
the victims. Despite this, over ninety
people died. The houses on the west
side of Crowthers Hill, like other
old tenements in the town, have
been demolished. The Primitive
Methodist Hall was here, then the
Scout Hut.

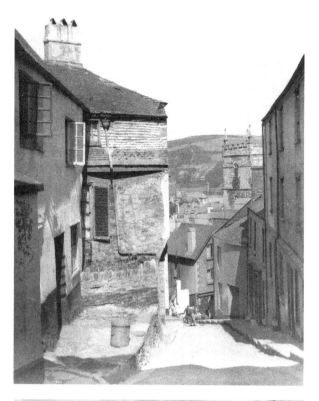

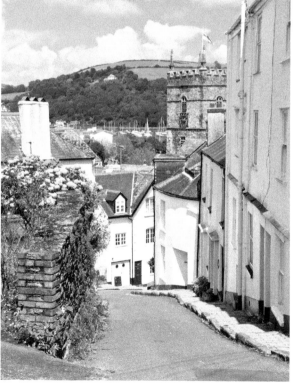

63

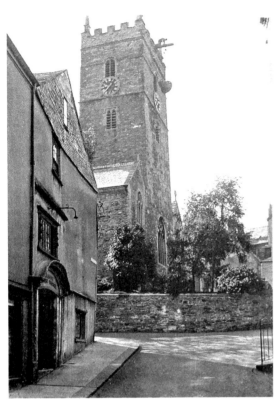

St Saviour's Church

Dedicated by the Bishop in 1372, the new chapel at St Saviour's was established after a long and complicated dispute. The rights of the mother church at Townstal to be the parish church were finally recognised, and the people of the port gained a place to attend Mass more easily. Major rebuilding and extension occurred in the 1630s; the bells were re-hung in 1938 (*seen here*) and a major restoration to the interior was carried out in 2014.

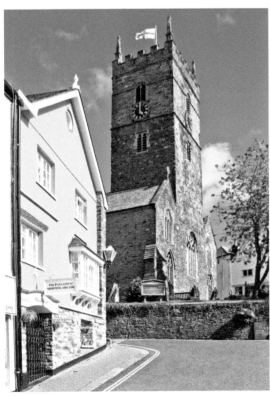

The Palladium

Renamed Anzac Street in 1917 following the king's announcement that the Royal family were relinquishing their German titles, Hanover Street led from St Saviour's church to the Foss. The Palladium, originally stables for the Castle Inn dating from 1774, was a cinema for only a short period of time, although it retains its name. A building opposite, in what is now the square, was the first Guildhall from 1370–1480, with the town gaol to the south of it.

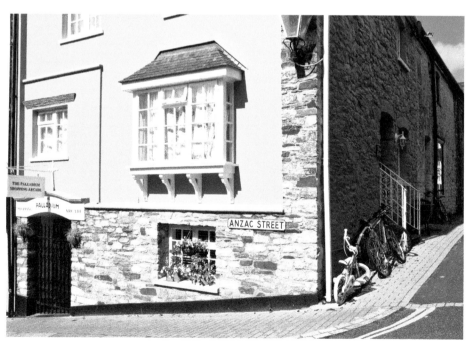

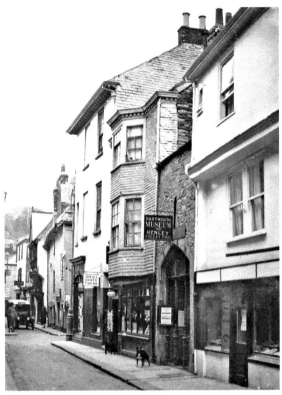

Anzac Street and The Henley Collection

William Henley (1860–1919) was an ironmonger with a shop in Foss Street. As a self-taught man of his time, he took an interest in music, architecture and science, and was a talented artist whose watercolours serve as a record of the town at the end of the nineteenth century. His sister Nellie's collection of his life's work was housed in the Henley Museum in Anzac Street. It is now on display in the Dartmouth Museum, in a room modelled as a gentleman's study of the period, where his collection of microscopic slides, books and drawings can be seen and handled.

Foss Street

A deep creek separated the two areas of Clifton and Hardness in medieval Dartmouth until a dam was built along the current Foss Street in 1243. The Foss provided tidal water power to drive one mill, and later a second. Damming the Foss meant the mill pond gradually filled with silt, and in 1828 a new market was built on the reclaimed land. The 1943 bomb destroyed the Tudor House (*right*) in Foss Street. In the 1980s, Foss Street was pedestrianised.

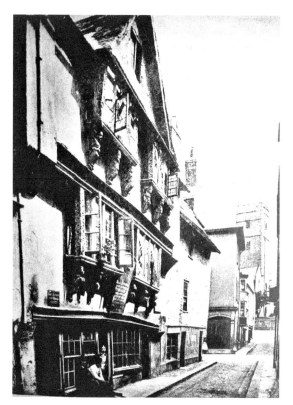

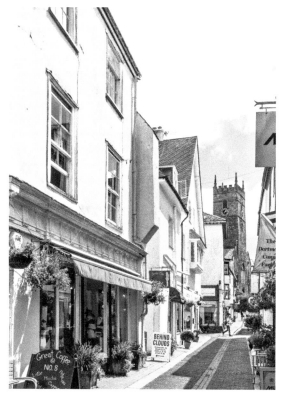

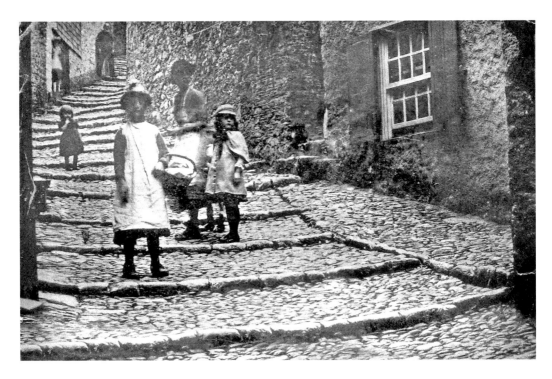

Brown's Hill Steps

Steep and slippery, the aptly named Slippery Cause was one of the few causeways for people and packhorses to get from the quay and market to Tunstal (now Townstal) until 1825. Now called Brown's Hill Steps, repaved and a little less slippery, but still quite steep, this ancient route up the hill from Broadstone has become known for its stunning flower displays in summer.

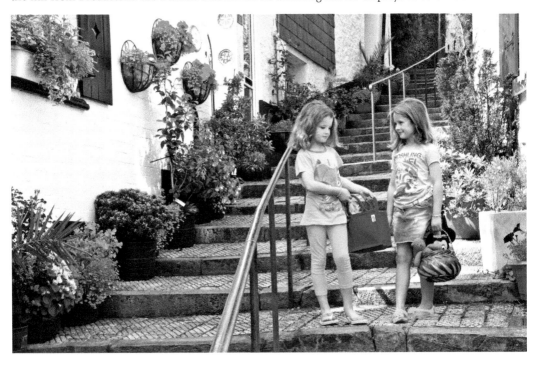

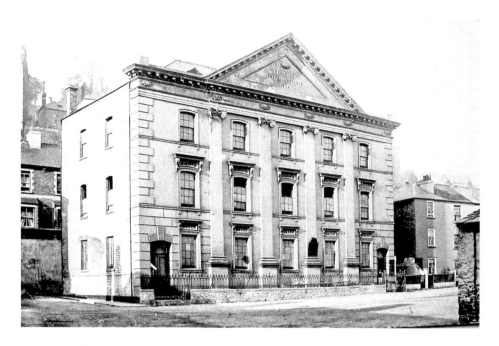

Methodist Church

The history of the Methodist church in Market Square dates back to 1782, but the Wesleyan chapel (*above*) was built in 1874. Its enormous size is not appreciated until compared with the three-storey house on the right. With the union of Dartmouth's three Methodist chapels in 1932, the chapel became the Methodist church. The last service was held here in December 1982, and a prolonged debate began on whether the building should be retained or demolished. The issue was resolved in 1991, when the owner surreptitiously attempted to bring down the building with explosives. He was prosecuted and went to prison. The unstable building was demolished to make way for Wesley Court flats.

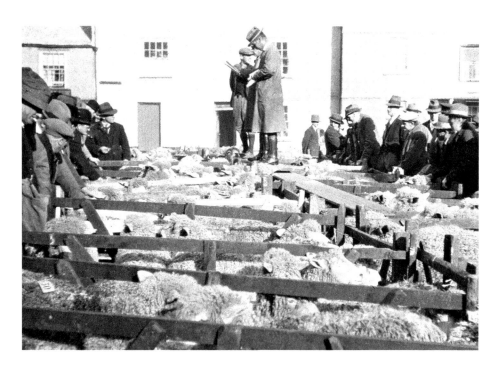

Fat Stock Show

The annual Fat Stock Show in December has been held in the market for nearly 100 years, giving local farmers the opportunity to showcase their prize sheep, cattle and dressed poultry. Residents can acquire their Christmas goose or turkey in the auction following the presentation of prizes. Until the 1960s, there was also a monthly animal market. Small shops now line the market, and there are still regular market days featuring local produce, crafts, plants and household items sold at stalls both inside the market and in the square.

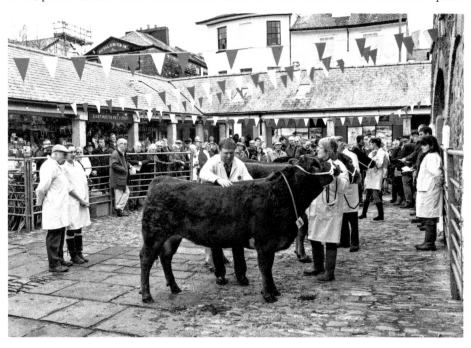

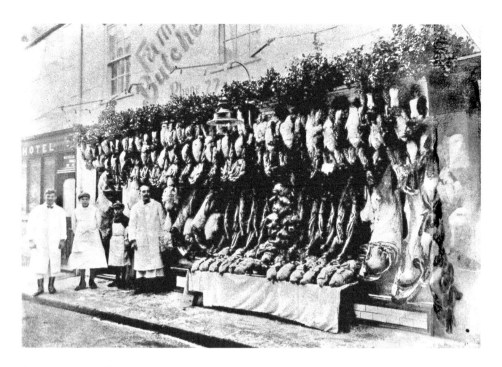

Dartmouth Butchers

Not so long ago there were ten butchers in Dartmouth, supplied by five local abattoirs. Many of these shops can still be spotted by the brass rail under the window, which is typical of a butcher's shop. Only one, however, remains a butcher's today. It can be found in Victoria Road, in the same premises used by the appropriately named Cutmore family, whose three generations were local butchers for seventy years. Pictured in the 1920s (*above*) when called The Family Butcher, Dartmouth Butchers is still supplying locally sourced meat.

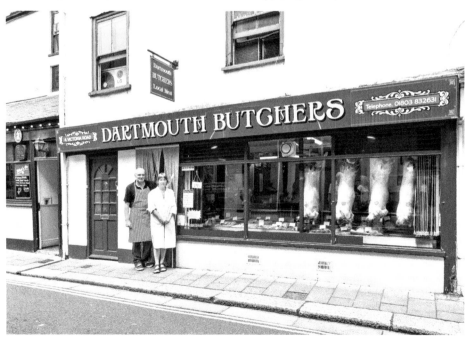

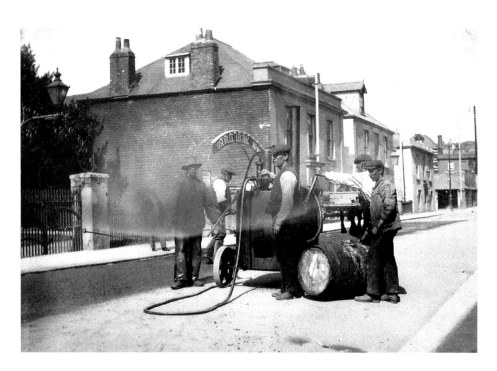

Victoria Road

Once the Mill Pool was drained in 1826, the Kingsbridge and Dartmouth Turnpike Trust built the new road up the valley, finally giving carriage access to the town. The current Conservative Club, built around 1830, was used as a library, and the neighbouring Seale Arms was a bank between 1836 and 1844. The house next to the Seale Arms was built by Thomas Henley. After 1886 it became the Dartmouth Liberal Club. Above, Victoria Road is being resurfaced around 1913.

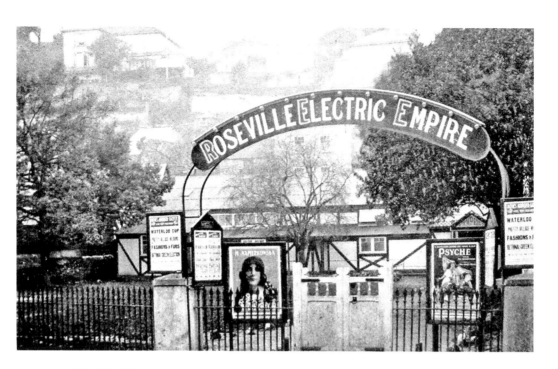

Roseville Electric Empire

A new venture for Dartmouth, the Roseville Roller Rink opened in Victoria Street in 1909. There were three skating sessions per day and ball-bearing skates could be hired for 5*d*. Although *The Chronicle* wrote that 'rinking in Dartmouth has come to stay', by 1913, the attraction had become Dartmouth's first cinema, renamed the Roseville Electric Empire. Roseville Lawn or Victoria Lawn also had tennis courts at one time, but is now the site of Churchill Court in Victoria Road.

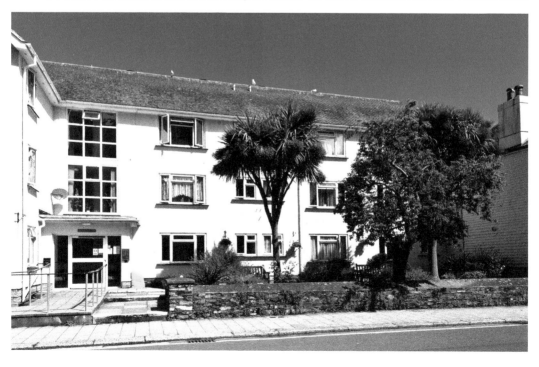

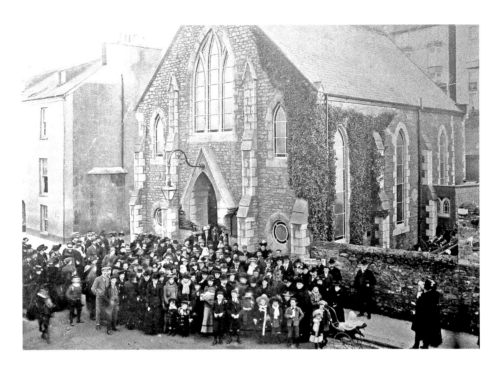

Primitive Methodist Chapel

The Bible Christian Methodists built this chapel in Victoria Road beside the Subscription Rooms in 1867, but by 1878 they had sold it to the council for a guildhall (the fourth one) and moved to Newcomen Road. When the Subscription Rooms became the fifth guildhall in 1901, the Primitive Methodists bought the building. It remained as the Primitive Methodist chapel until 1932, when all the branches of the Methodist church united to use the church in Market Square. The site was a garage from 1948, then housed Tozer Printers, but has recently been redeveloped as offices and flats.

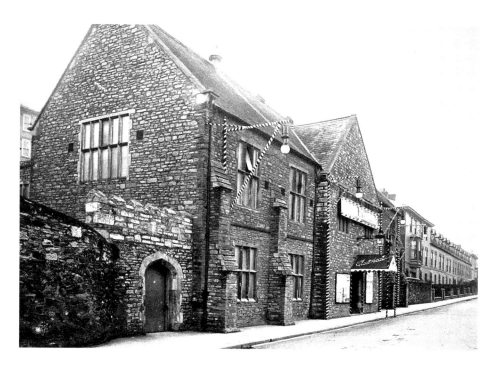

The Guildhall

There have been five guildhalls in Dartmouth since 1370. The latest and current one, used since 1902, was built in 1849 by public subscription. Known as the Subscription Rooms, it was initially leased as a British and Foreign co-educational school. It contains a wood-panelled and portrait-lined council chamber and large first-floor room used as a meeting room, theatre and ballroom for private and civic functions. The balcony, now covered in floral displays every summer, was a later addition. New council offices were added in 1992 on the west end.

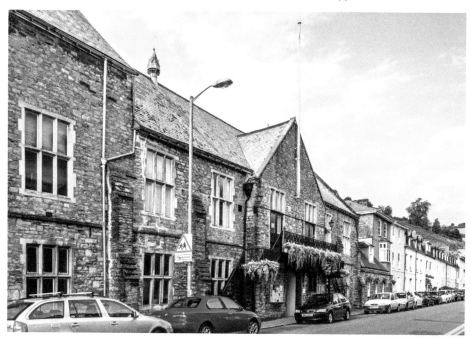

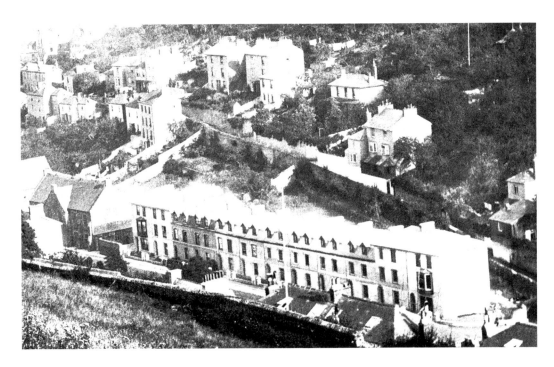

Mansard Terrace

The terrace of twelve houses on Victoria Road west, of the Subscription Rooms (now the Guildhall), was built between 1867 and 1874. It has changed little over the intervening years. The area on the opposite (north) side of Victoria Road was a nursery garden, but is now the bowling green and children's playground. By 1881 New Road, not renamed Victoria until the Diamond Jubilee in 1887, was almost fully developed as far as Ford Cross, just a bit further to the right here.

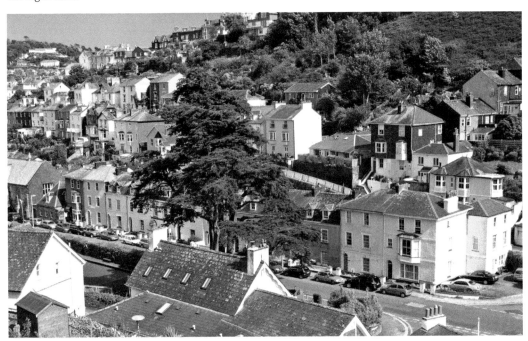

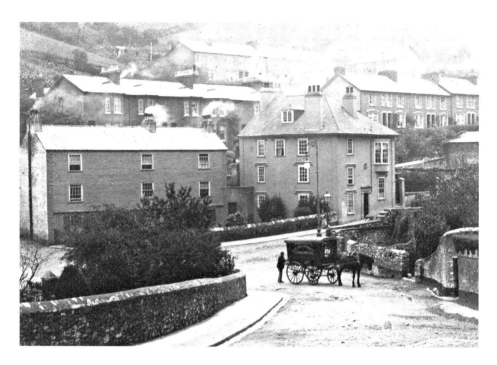

Ford Cross

Ford Cross or Ford Green is located at the bottom of Vicarage Hill where it meets Victoria Road. Until the 1820s when the Mill Pool was filled in, it was the only place to cross from Clifton to Hardness, west of the Foss. A small weir held back the fresh water at the crossing point, and the south facing meadow on Vicarage Lane was long used as a place for washing and drying clothes. The Mariner Almshouses are said to have been built as early as 1599, then rebuilt around 1803. They were originally called gift houses.

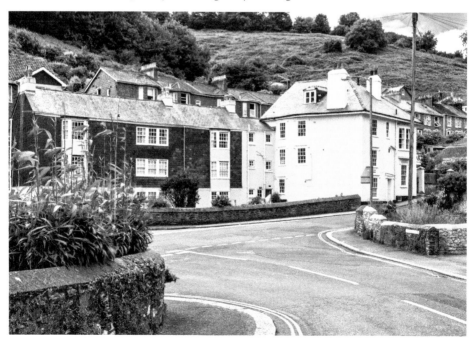

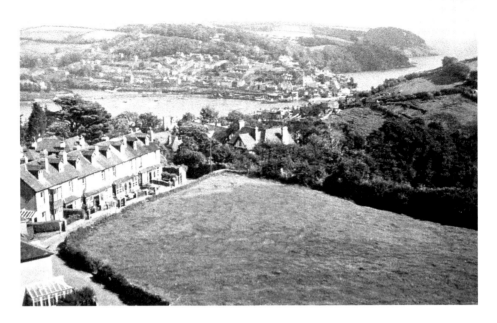

View from St Clement's Church Tower

In the Domesday entry of 1086, Townstal was valued at 10s and had two plough teams, two slaves, five villagers and four smallholders with six cattle, forty sheep and fifteen goats. Townstal was probably a safer place to live than on the river or coast, and Dartmouth's importance as a port was yet to be established. The FitzStephen family, lords of nearby Norton Manor, dealt with the affairs of Townstal for 150 years. Their bailiff held a court where annual rents and fines were paid, and changes in tenancies recorded. Above is the view from the church tower prior to 1964.

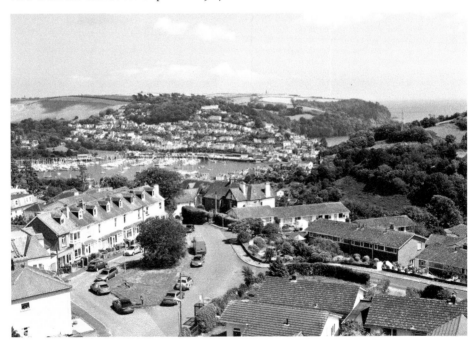

St Clement's Church, Townstal

Part of the estate of William FitzStephen of Norton, the wooden church at Tunstal was given to Torre Abbey in 1198 by Lord William. The Abbots of Torre, who appointed the vicar of Townstal for nearly 300 years, began building the stone church, dedicated to St Clement by the Bishop of Exeter in 1318. During the Civil War, Dartmouth supported Parliament, and guns were mounted on the top of church towers as defences. After three years of occupation by the Royalists, Dartmouth was once again back in Parliamentarian hands in 1646, despite St Clement's church being well defended by Royalists, with 100 men and ten guns.

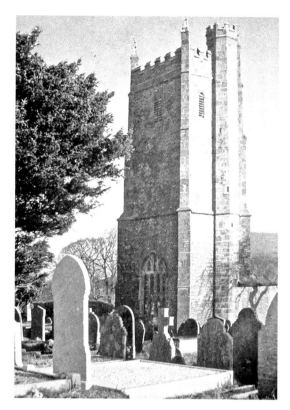

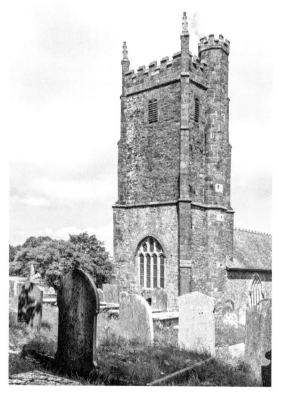

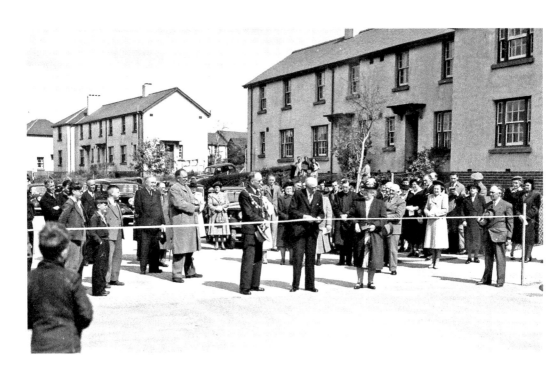

Townstal Housing

Slum clearances in town meant an acute need for housing, and in 1929, the council began building Townstal Crescent and Britannia Avenue. The expansion of the Townstal Estate continued after the war and by 1961, there were 281 houses on the estate. Above, Mayor Bertie Lavers is opening the Britannia Avenue extension in 1956. The temporary houses, built using Cornish concrete in 1947, did not stand the test of time; they were rebuilt in the 1990s. In 2000, Seymour Drive (*below*) was built on the west side of the estate.

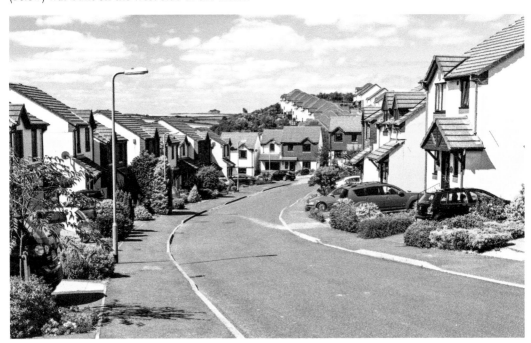

Churchfields

The 1960s and 1970s were a time of essential expansion in housing development for Dartmouth and Townstal. The Churchfield Estate, begun in 1964 (*above*), was extended to the west in the early 1970s. On the hillside below Churchfields, Higher Broad Park was developed, and the Scout headquarters were built in the Broad Park quarry. Thirty-eight houses were added to the Rock Park Estate for BRNC staff.

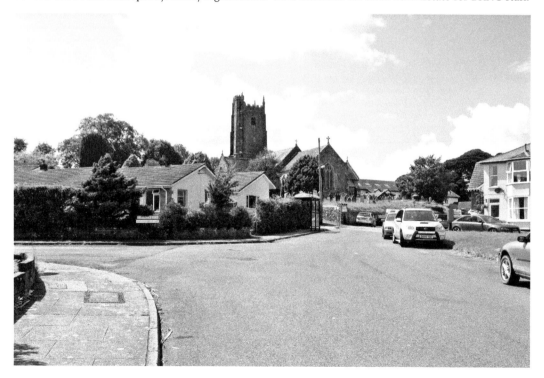

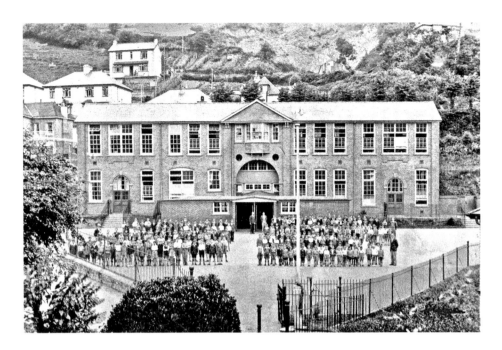

Dartmouth Schools

Dartmouth has always had a number of schools, including the Boys' School in Victoria Road (*above*), a grammar school at Ford Bank, a primary school in Higher Street and a Catholic school, first at St John's church and later in Milton Lane. A new community college, and then a primary school, were built in Milton Lane in 1974, but the Boys' School continued to be used as the lower school. Finally, in 1987, the Boys' School was demolished and replaced by School Court flats. All the schooling was then in Milton Lane, where the Dartmouth Academy, with new buildings completed in 2014 (*below*), provides education, from nursery stage right through to sixth-form, for most of Dartmouth's young people.

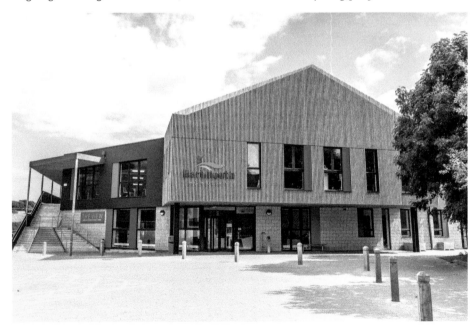

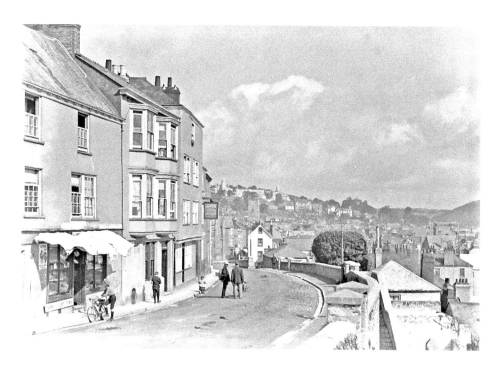

Southtown

Originally part of the manor of Stoke Fleming, Southtown was given to the borough to help defend the castle. Manor Gardens now marks the spot where John Southcote built the Manor House in 1727. It was demolished for further road widening in 1905, but, as motorists today can confirm, it never happened. In the 1860s, other old houses in Lower Street, including Thomas Newcomen's house, were demolished to link Southtown to the quay, and a large retaining wall and bridge structure were built to support what is now Newcomen Road.

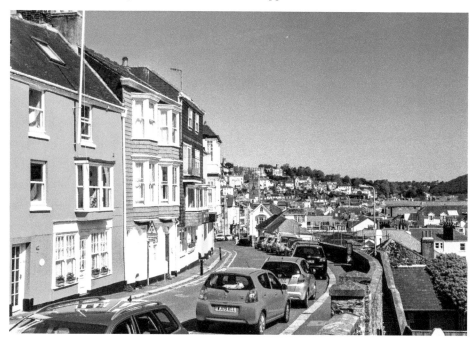

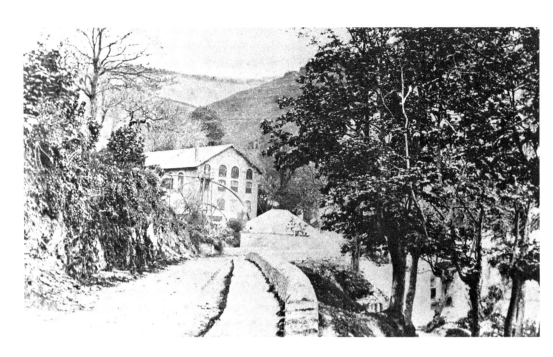

Warfleet Cove

Wel-flut, meaning 'watery flood', was a busy community with ropewalks, lime kilns, shipbuilding and several mills. The new paper mill, built in 1819 and powered by the largest waterwheel west of Bristol, printed banknotes for the Dartmouth Bank before becoming a brewery from around 1832. In 1948, the brewery became a pottery, known in more recent years for its gurgling fish jugs. Employing up to 200 people at its most productive, Dartmouth Pottery closed in 2002 and the land was redeveloped as housing, retaining the old pottery building. The waterwheel, visible if you look closely above, was sold for firewood in 1872.

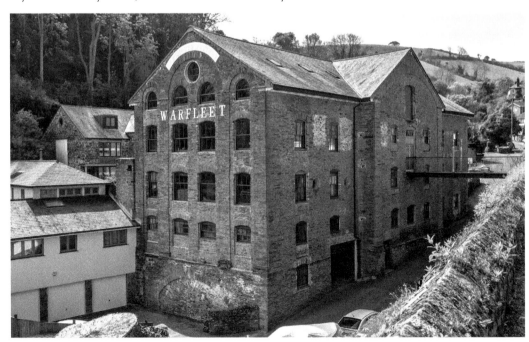

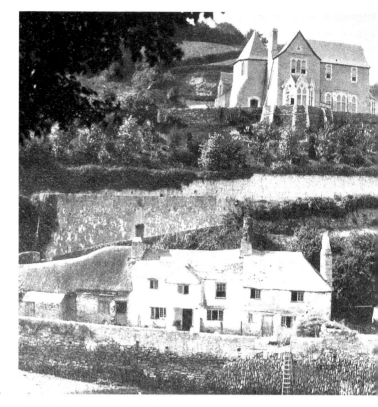

Warfleet House

Warfleet Farm House, with a quay for landing merchandise, was home to the Roope family, and brasses in St Petrox show John Roope and his daughter, Dorothy. With the growth of yachting in the 1800s, villas with views of the river began to be built in both Kingswear and Dartmouth. Warfleet House, above the farmhouse, (shown here c. 1860) was one of these. In 1875, Andrew Bridson, fifteen-year-old son of the then owner of Warfleet House, built a 600-ft-long model railway in the garden, complete with fifteen stations, level crossings and sidings. In 1944, Warfleet House became one of several 'Wreneries', housing members of the W.R.N.S.

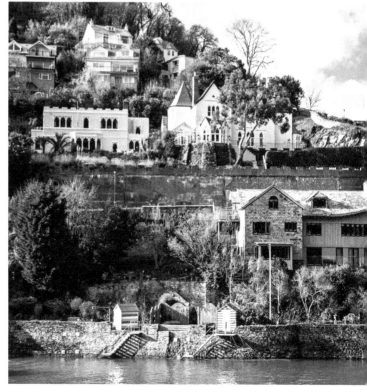

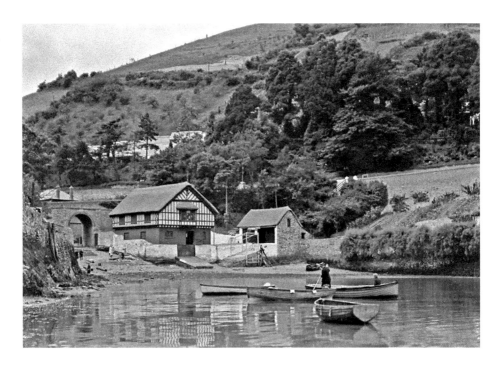

Warfleet Boat House

Warfleet House, overlooking the cove, was bought in 1880 by London property developer Sir Charles James Freake. He was a friend of the Prince of Wales, later known as King Edward VII. He demolished the stables and built Warfleet Lodge, with its ballroom and billiard room connected to the House by an elevated gallery. He also built the boathouse at the head of the cove, reputedly used by the Prince and Lily Langtry.

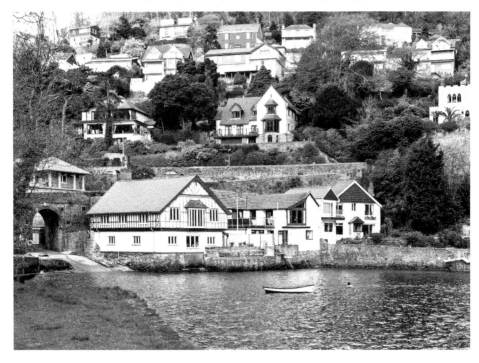

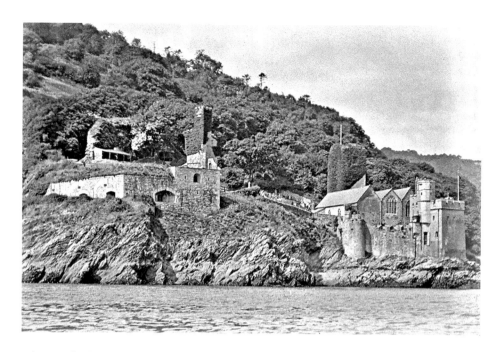

John Hawley's Fortalice

As a customs official, Geoffrey Chaucer visited Dartmouth in the 1370s. It is possible that he based his 'Shipmanne of Dertemouth' character in *Canterbury Tales* on John Hawley, fourteenth-century landowner, merchant, privateer and politician. During one of his fourteen terms as mayor, Hawley organised the construction of the fortalice or fort at the mouth of the river, which predates the current castle by 100 years. The remains of the 2-metre thick curtain wall of the fortalice can be seen above left, and again below, as the backdrop for the Inn Theatre Company's annual Shakespeare Week.

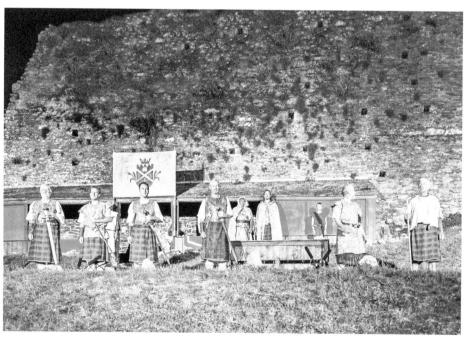

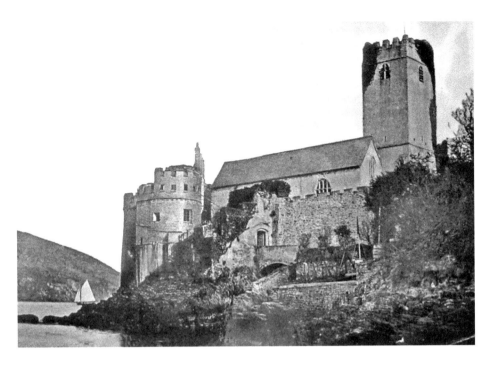

Dartmouth Castle

The developing technology of heavy cannon made Hawley's fortalice obsolete, and in 1481, Edward IV made a grant for the construction of a new tower and bulwark. A few years later, the new king, Henry VII, gave a further grant of £40 and ordered the town to complete the work with more speed, and arm it with guns. This was the first castle in England designed for artillery, and gunports that could cover the whole field of fire were put as close to the waterline as possible. A castle on the Kingswear side was built around this time in a similar style to the square Dartmouth Tower.

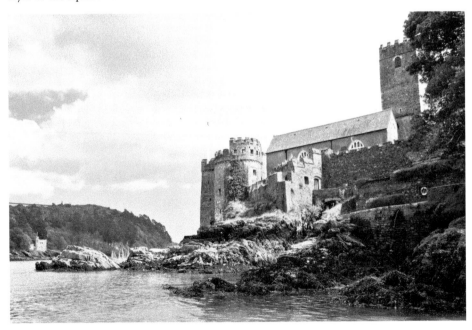

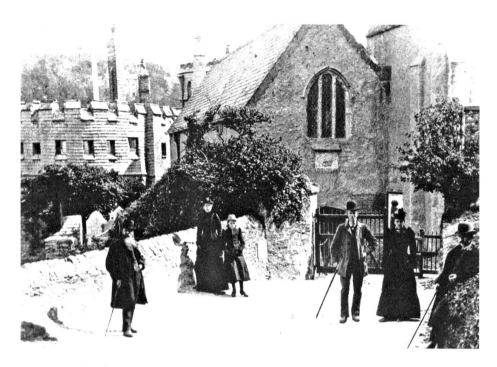

St Petrox Church

Tucked in behind the castle, the church at the river mouth may have begun as a primitive chapel and holy well. The relics of St Petrox may also have come through the port on their way to Bodmin in 1177. The church was rebuilt in 1641, with the addition of the tower, two arcades and windows on the north side. Inside are brasses and burial slabs of the local merchant families of Roope, Holdsworth and Newman. Services are held throughout the summer, and St Petrox is a popular church for Dartmouth weddings.

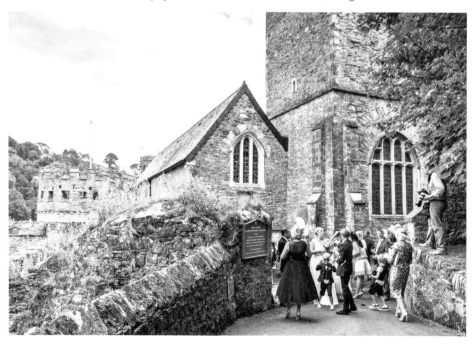

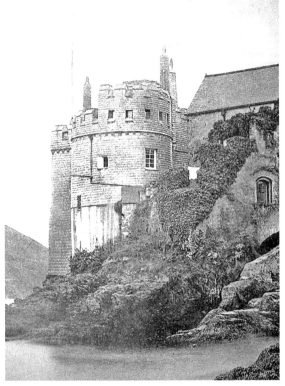

Dartmouth Castle Lighthouse

From 1837, part of the responsibility of the garrison at Dartmouth Castle was to maintain the harbour light, located in a small turret of the castle facing the harbour entrance. A window in the turret was also the port's leading light. An annual payment of £20 was made by a local MP for the maintenance of this service, but remarkably, when this payment ceased, Dartmouth was left without a harbour light until the battery lighthouse was built nearby. Exterior slate was hung in 1871 for improved weatherproofing, and the garrison gained more fireplaces, chimneys and sanitary facilities at the same time.

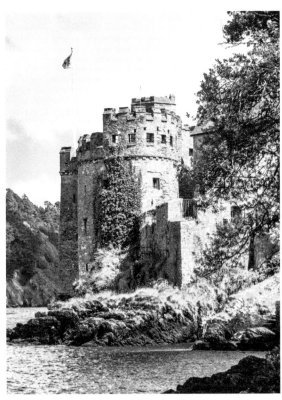

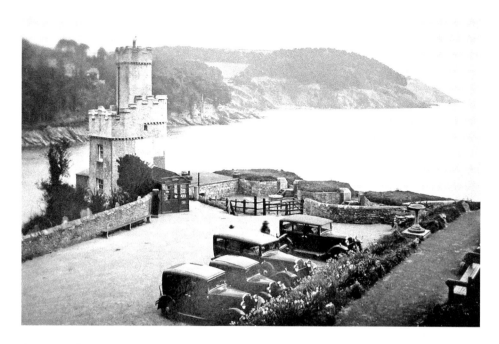

Battery Point

The tower at the old battery was built by the townspeople of Dartmouth as a lighthouse in 1856. However, the light could not be seen from the south west, and within thirty years it was replaced by navigation marks on the Kingswear side. The Point was once called Lambert's Bulwarke, and in the late 1740s twelve guns pointed seaward, watching the entrance to the harbour from the renamed Grand Battery. English Heritage now have a gift shop and ticket office in a gun house used during the Second World War to house one of two guns protecting the harbour. In the Second World War a searchlight was also mounted to shine on any invaders.

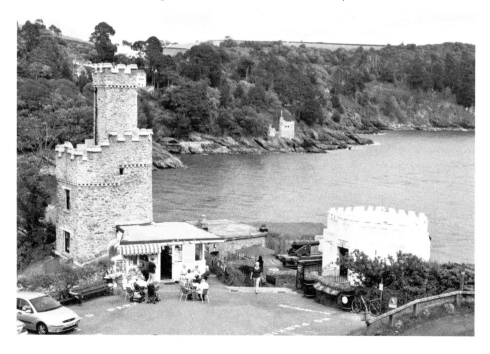

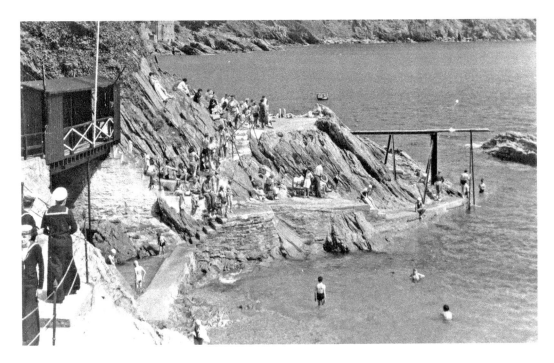

Castle Cove

As the closest bathing cove to the town, Castle Cove, with its small beach and rocky bathing platforms, has long been popular with locals. The Swimming Club was based here in 1893 and built a hut over the rocks. Over the years, rock slips have closed the steep steps to the cove on numerous occasions, and in 1999 damage by winter storms once again stopped access. Following seven years of strong protests by the 'Save Castle Cove' campaign group, repairs by Devon County Council returned the cove to local use, although the bridge to the rocks is no longer accessible at high tide.

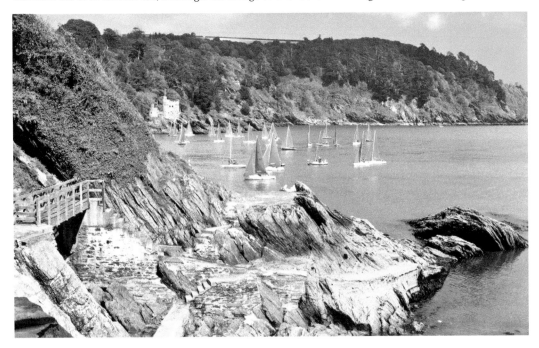

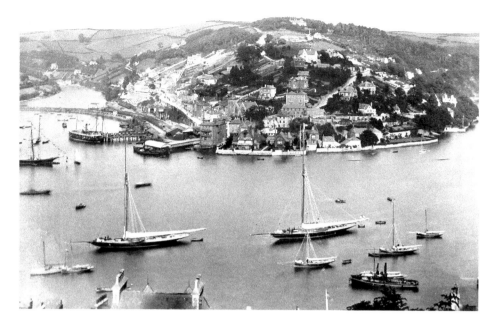

Kingswear

It is impossible to be in Dartmouth and not be aware of Kingswear, the village sharing Dartmouth's stunning river location. South of the church dedicated to St Thomas in 1170, is Kittery Quay, which was once packed with merchant houses, warehouses and wharves. Ships could access Kingswear at all states of the tide, and pilgrims on their way to the tomb of St Thomas at Canterbury would land here from overseas. Now the marina and the fish quay dominate the northern foreshore, and Victorian villas fill the hillside.

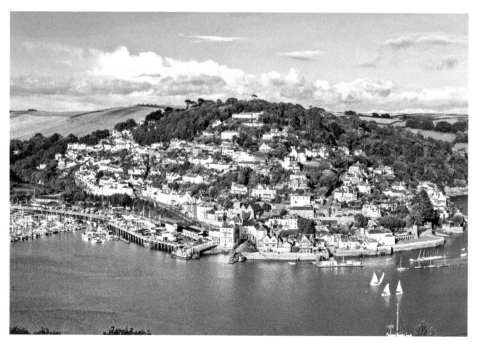

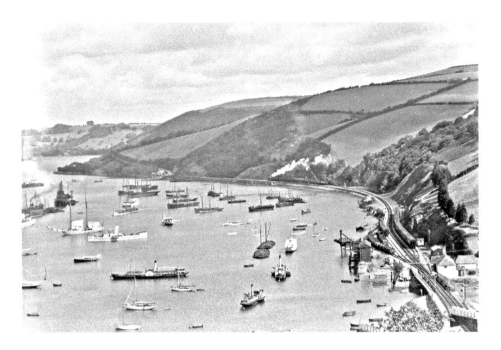

The Railway at Kingswear

The coming of the railway to Kingswear in 1864 brought great change to the village as old buildings were demolished and the foreshore rebuilt. The Royal Dart Hotel on the river next to Kingswear station provided accommodation for rail passengers sailing abroad on passenger ships leaving from the river. Coal was loaded from the colliers onto rail trucks for the Torquay gasworks until the 1960s. Regular passenger service ceased with Beeching's cuts, but the line was taken over by the Dart Valley Railway Company in 1972 as a tourist attraction running steam trains. This is now a popular outing combined with river trips.

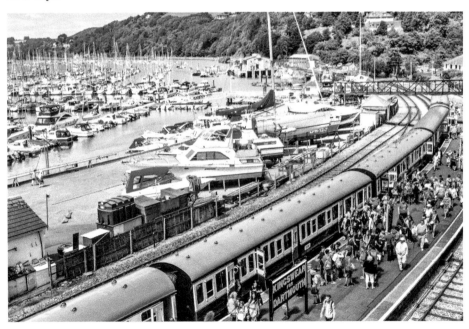

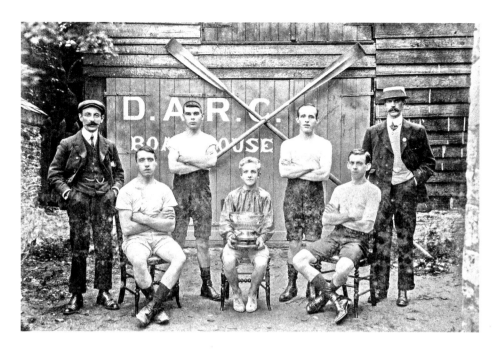

Dartmouth Amateur Rowing Club

Dartmouth Amateur Rowing Club, based at their clubhouse behind the Floating Bridge Inn for more than a century, was established in 1869, nearly fifty years after the first recorded rowing race on the Dart. Over the years, DARC have won over 2000 trophies and were the first club to win all the West of England ARA Men's Championships in 1994. DARC Junior Rowers also have a long and successful history. The 1909 season juniors are posing outside the boathouse after winning the Dartmouth Challenge Bowl. The long history of rowing on the River Dart continues today, and is an important part of Dartmouth Regatta.

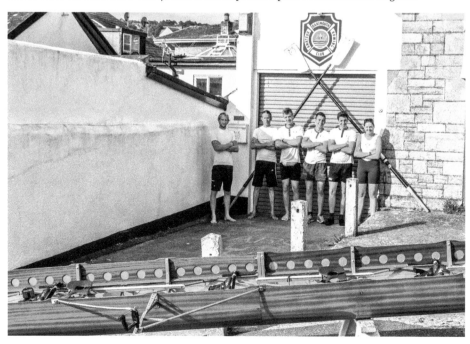

Dartmouth Royal Regatta

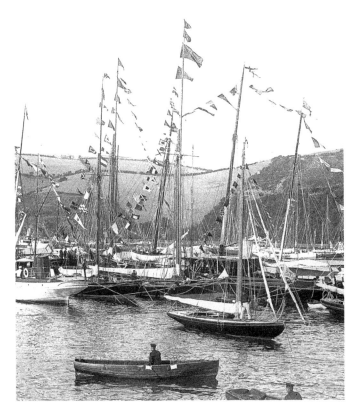

Although the first Dartmouth Regatta officially dates back to 1834, there is a record of racing at Dartmouth in 1822 when three sailing races and one rowing race for gigs were held. This first regatta featured a band playing at the castle, and a ball was held. Gaining the title Royal in 1856 after Queen Victoria visited, Dartmouth Regatta is now a three-day event every August, attracting 18,000 visitors. With sailing and rowing at its heart, regatta traditions also include air displays, fireworks, balls, fairground and stalls, swimming, tennis, golf, road racing events and activities for children.

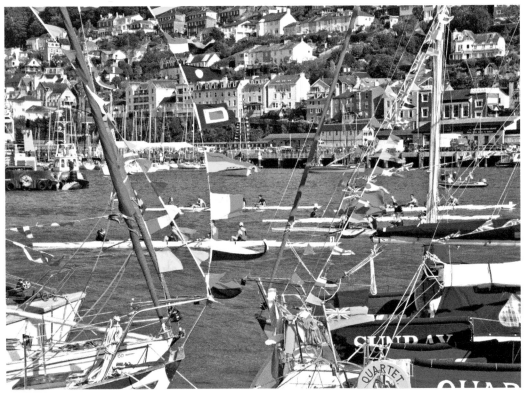